UNDERSTANDING THREE DIMENSIONS

UNDERSTANDING THREE DIMENSIONS

Jonathan Block
Parkland College, Champaign, Illinois

Jerry Leisure

PRENTICE HALL, Englewood Cliffs, New Jersey 07632

Library of Congress Cataloging-in-Publication Data

BLOCK, JONATHAN (date)
　Understanding three dimensions.

　Includes index.
　1. Design.　2. Form perception.　3. Models and
modelling.　4. Visualization.　I. Leisure, Jerry.
II. Title.
NK1510.B58 1987　　　745.4　　　86–12202
ISBN　0–13–937202–4

Editorial/production supervision
　and interior design: F. Hubert
Cover design: Ben Santora
Manufacturing buyer: Ray Keating
Cover art: Isamu Noguchi, *Sunken Courtyard*.
　Beinecke Library, Yale University.
　(Courtesy of Office of Public Information,
　Yale University; photo by T.
　Charles Erickson)

© 1987 by Prentice-Hall, Inc.
A Simon & Schuster Company
Englewood Cliffs, New Jersey 07632

Printed in the United States of America

10　9　8

ISBN　0-13-937202-4

PRENTICE-HALL INTERNATIONAL (UK) LIMITED, *London*
PRENTICE-HALL OF AUSTRALIA PTY. LIMITED, *Sydney*
PRENTICE-HALL CANADA INC., *Toronto*
PRENTICE-HALL HISPANOAMERICANA, S.A., *Mexico*
PRENTICE-HALL OF INDIA PRIVATE LIMITED, *New Delhi*
PRENTICE-HALL OF JAPAN, INC., *Tokyo*
PRENTICE-HALL OF SOUTHEAST ASIA PTE. LTD., *Singapore*
EDITORA PRENTICE-HALL DO BRASIL, LTDA., *Rio de Janeiro*

CONTENTS

LIST OF ILLUSTRATIONS

PREFACE

This book is the result of continuing efforts to find a text that adequately deals with the special issues of three-dimensional design. While there are many excellent books that deal with both two- and three-dimensional design, we have been frustrated in our efforts to find one that recognizes the essential differences between them.

Two-dimensional design is limited to events that take place within a delimited field on a flat surface. The traditional "elements and principles" enable us to understand and control the events within that field. At the heart of two-dimensional design is the issue of illusion.

Three-dimensional work, on the other hand, is characterized by its physicality. Three-dimensional objects exist in real space; they are tactile; they are responsive to variations in light and point of view; they elicit response to material as well as to form. Engineering is an issue of believability as well as of manufacture.

The primary goal of this book is to help students develop an understanding and appreciation of the interaction of form in space and ways to manipulate it. There is, however, a hidden agenda as well: This is the students' attitudinal and conceptual development. As most of the graduates of even the most professional schools will not be directly involved in art or art-making a decade after graduation, it is important to help them develop attitudes toward creative activity that will be useful regardless of their future professions.

The goals of introductory courses in art and design are varied, but they all have some things in common. Among these is a desire to create a shared vocabulary, both visual and verbal, to facilitate further work. This shared vocabulary serves as the basis for the constructive criticism and exchange of ideas that are important ingredients in the formal study of art.

While a vocabulary for the consideration of two-dimensional images is relatively well established and forms the core of most courses in two-dimensional design, this is not the case with three-dimensional design. Too often this lack of clear vocabulary results in curricula that focus exclusively on structures or materials, never establishing a basis for looking at and responding to form on a purely visual level.

In the world of diplomacy a *protocol* is "a preliminary agreement which serves as the basis for further negotiation." Protocol also refers to the rules of etiquette. While there is nothing sacred about manners, observance of the rules of politeness facilitates social interaction, reducing friction and encouraging productive communication.

It is our hope that the principles and approaches outlined in this text can serve as a useful protocol for three-dimensional design.

Just as a protocol serves as a starting point in diplomatic negotiations, so should this text be viewed as a starting point for the development of a shared approach to looking at form.

Acknowledgments

I am indebted to many without whose presence this book would not have come to be: The editorial staff at Prentice-Hall for taking my initial musings seriously, especially Bud Therien; Tom Schlotterback and other colleagues for reviewing the manuscript; Jerry Leisure for holding up his end; Frank Hubert at Prentice-Hall for transforming typescript to manuscript to book. Finally, I wish to thank my best critic, constant reviewer, endless source of encouragement, and scourge when I need it, my wife.

—Jonathan Block

I wish to acknowledge the invaluable help of Bud Therien and Frank Hubert at Prentice-Hall. Their indefatigable patience and professional guidance made the completion of this book possible. I also wish to thank the many galleries who gave their time and assistance in procuring much of the contemporary photographic material that was so essential to the realization of this book. Finally, I would be remiss not to mention the incredible forbearance of my family in not abandoning me to my own means during what must have seemed endless months of distraction and business.

—Jerry Leisure

UNDERSTANDING THREE DIMENSIONS

1. INTRODUCTION

Where humans have been we find tools and images. From the cave paintings at Lascaux to Stonehenge, from Easter Island to Machu Pichu, humans have left their mark on the planet through the restructuring of the environment. Artists and designers are actively involved in this endeavor. The marks of our passing can be found from the most remote places on the planet to the fringes of the solar system. It is our work that will mark this age for those who come after us. As definers of our times we have a special responsibility. Future generations will judge this age in terms of our actions.

Successful work in any medium is characterized by three things: *intention, clarity,* and *specificity.*

We immediately recognize in organized work the fact that it is intentional: The maker—artist or designer—has arranged the material

Figure 1. Paleolithic cave painting (15,000–10,000 B.C.). Lascaux, France. (Courtesy of the French Government Tourist Office)

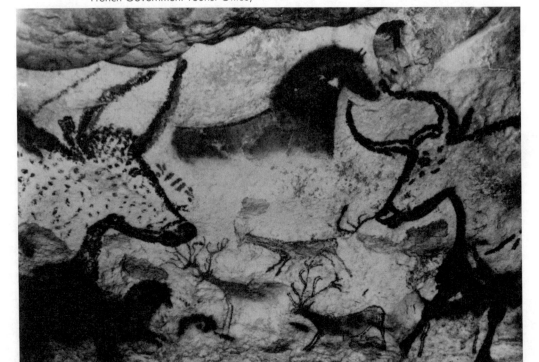

before us with clear goals in mind. What we see reflects those goals and is not merely a random agglomeration; choices have been made and measured against the maker's goals. Whether or not we are able to understand the specific intent of the builders of Stonehenge, we never doubt that what we are presented with is an intentional array.

Our understanding of the intention of an object is dependent upon the clarity of the expression. In order to communicate effectively we must be aware of the ways in which our choices contribute to, or inhibit, the clarity of our intent.

Finally, it is important that our goals be specific. The more particular our statement, the narrower our goals, the more likely we are to be successful in making our intention clear.

It is the goal of this book to increase our understanding of the nature of form and formal decision making. In order to make formal decisions responsibly, it is necessary for us to understand the nature of our choices in dealing with material, for it is through our choices as designers and artists that we imbue our products with value and purpose.

Figure 2. Stonehenge, England. (Courtesy of the British Tourist Authority)

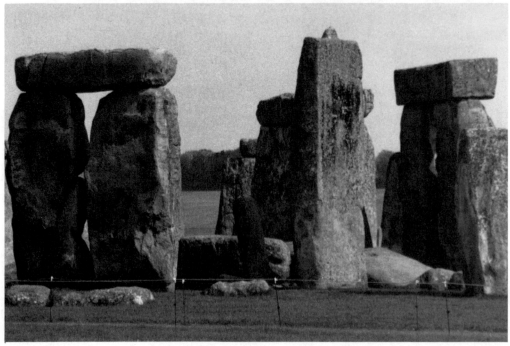

Figure 3. Statues, Easter Island. (Photo by Eugene Gordon)

Design is the process of choosing appropriate means to achieve our goals. To develop an awareness of the ways in which these choices can be most effectively made, the book begins with a discussion of creative decision making, the process of *conceptualization*—Where do ideas come from? How do we begin?

The discussion of form deals with the three basic elements *line, plane,* and *volume*. After defining basic characteristics of the first three dimensions of form and looking at ways in which each dimension relates to the others, we discuss some attributes of three-dimensional objects, such as *mass, radiation,* and *gesture*.

Next we look into the organization of form in space, paying special attention to the role of perception—how we see forms.

This leads to the exploration of *modifiers* and *unifiers* of form, focusing on those elements that define, reinforce, or contradict the essential contrasts through which form is understood.

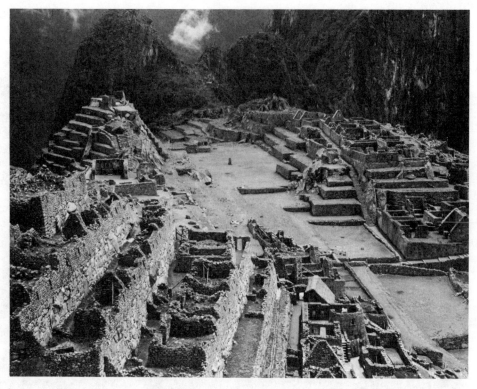

Figure 4. Machu Pichu, Peru. (Photo by Eugene Gordon)

What we seek to do is to open up the universe of possibilities available to artists and designers, to create an awareness of the range of choices and decisions that can be made in the process of visual design in three dimensions. We are by no means trying to define or limit the field. Choices we have made with respect to topics to consider, illustrations, etc., should be viewed as a jumping-off point, a beginning for personal explorations.

The ways of seeing and understanding form that this book attempts to foster are applicable to all activities that involve working with form in space. The same principles that are used to organize sculptural form can serve as a starting point for work in design, architecture, and engineering.

We have attempted to restrict our consideration to objective qualities of form, avoiding value judgments as much as possible. We have chosen pieces to illustrate certain limited points, but do not intend to suggest that the artist's intent was related to our use of the work. We are aware that language, especially when applied to art, can sometimes confuse as easily as it can communicate, and we have tried to use terminology consistently.

2. CONCEPTUALIZATION

One of the questions most often asked of artists is, Where do your ideas come from? In this chapter we explore the process of finding and developing ideas in preparation for rendering them in three dimensions.

We first discuss the idea of originality and sources for ideas, then sketching and modeling as developmental tools, and finally the creative process and its several steps: *acceptance and definition, ideation,* and *judgment.*

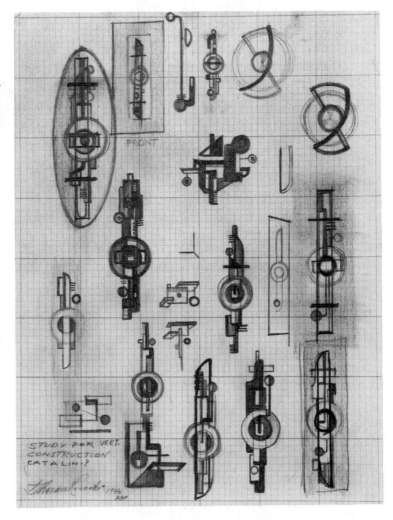

Figure 5a. Theodore Roszak, *Study for Vertical Construction* (1940). Pencil, 8¼" × 6⁵⁄₁₆". (Collection of Whitney Museum of American Art; gift of Sara Roszak; acq. # 78.18; photo by Geoffrey Clements)

Figure 5b. Theodore Roszak, *Sheet with Studies for Vertical Construction* (1940). Pencil, 6⁵⁄₃₂″ × 8¼″. (Collection of Whitney Museum of American Art; gift of Sara Roszak; acq. # 78.20; photo by Geoffrey Clements)

Figure 5c. Theodore Roszak, *Construction Work Drawing* (Vertical Construction) (1940). Pencil, 3⅜″ × 4⅞″. (Collection of Whitney Museum of American Art; gift of Sara Roszak; acq. # 78.19; photo by Geoffrey Clements)

Originality and Sources

Ideas are where you find them. Have you ever looked at someone else's work and said to yourself, "I wish that idea were mine?" A designer or artist has the whole world as his source book. Our ideas arise from our experience—what we have seen, read, felt, heard. Our ideas spring from our experiences and our interpretations of them. Original ideas result from the forming of new relationships and connections; they enable us to see and relate to the world in new ways. To come up with original ideas we must avail ourselves of the richest possible range of knowledge and experience.

There are many rich sources of ideas for designers. Foremost among these is the work of other artists and designers. Artists have always drawn ideas from the work of their contemporaries and those who preceded them. To deny yourself access to this vast resource is to attempt to work in a vacuum.

When contemporary artists are asked to name artists whose work has had a great influence they often mention the "old masters." Even the most radical work of today is firmly rooted in the past. The library can be as valuable a source of ideas and inspiration as museums, galleries, or your sketchbook.

If we wish to understand the ways in which form can be combined, we need only look actively at the world around us. Eyes function as much more than radar to keep us from walking into walls. Vision need not be passive: It can be active, interpretive, and challenging.

Another good resource is fellow artists. Sometimes they are able to look at our work freshly and provide a different perspective on our problems and offer possible solutions. All too often we don't learn until critique time of valuable insights that could have been available much sooner. There is no need to wait for critiques to get response to our work: Communication with our colleagues should be an ongoing process.

Additionally, the fact that someone else has had an idea "first" does not preclude our pursuing the same idea, and imbuing it with uniqueness in the specific ways in which we present it. Rodin, often considered the father of modern sculpture, drew his primary inspiration from the late work of Michelangelo, who worked four centuries earlier.

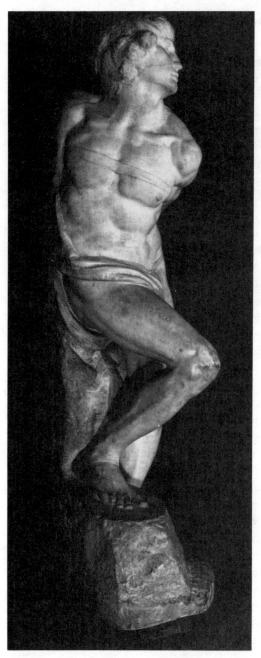

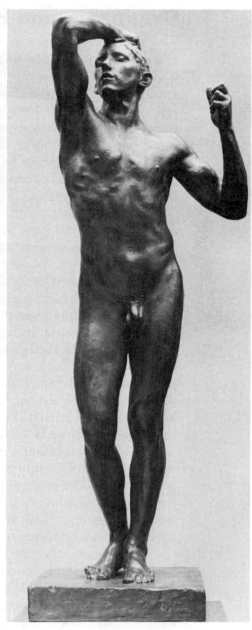

Figure 6. Michelangelo, *The Bound Slave* (1514–1516). Marble, 90″ high. (Musee de Louvre; photo by Archives Photographique)

Figure 7. Auguste Rodin, *The Age of Bronze* (1875–1876). Bronze, 71″ high. (From the collection of the Metropolitan Museum of Art; gift of Mrs. John W. Simpson, 1907, 07.127; all rights reserved, The Metropolitan Museum of Art)

Sketching and Modeling

A powerful tool for the development of ideas—the sketch—is often the least used. Through drawing and modeling you can develop multiple variations on an idea with a minimum of effort. You can sketch in minutes what would take hours to build. Through sketches you may discover new relationships in an object that can be incorporated into your design.

Models, built directly from easily manipulated materials, allow the rapid development of complex form and serve as a means of checking a project for unanticipated problems and of exploring alternative solutions. They can be useful in providing an understanding of potential mechanical and structural problems as well as an awareness of previously unanticipated formal relationships and contrasts within the form.

Sketches and models, as opposed to working drawings and maquettes, need not be viewed as prescriptions for the finished work. They can be valuable simply in giving us a feel for what we are about to do, and as an aid to thinking. It is useful, from time to time in the process of developing a piece, to pause and do a number of sketches of where you have been and where you may be going.

Figure 8. S. Shannonhouse, *Untitled* (1983). Bronze, approx. 17" high. (Courtesy of Stephen Wirtz Gallery; photo by M. Lee Fatherree)

The Creative Process

An important notion of creativity is the process of finding new or innovative responses to problems. While we are usually aware of creativity in others, we often fail to recognize its seeds in ourselves. Too often we are struck with the feeling, "I wish I were more creative." What is the process that enables some people to come up with "good" ideas while others always seem to get stuck in a rut?

The formal study of creativity is the domain of psychologists, philosophers, managers, scientists—all who are involved in the solving of problems. Much research has been done in this area, and many useful models of the process exist.

Artists and designers are often caught up in a "genius," or "muse" model. We may occasionally find ourselves "at a loss for ideas" and spend hours, days, or weeks waiting for a good idea to present itself. While it is true that good ideas often seem to spring to mind unbidden, what we seek are means to direct and control the creative process—especially when the mind seems unresponsive.

One useful model of the creative process breaks it down into a series of steps: *acceptance and definition, ideation,* and *judgment.* It is this model that we are exploring here.

The key to the creative process is the separation of analysis or judgmental thinking from the various stages of the process. Judgment, while essential to the creative process, often inhibits creative and innovative thinking.

ACCEPTANCE AND DEFINITION

Before proceeding in a problem-solving situation, it is important to accept the problem consciously. At first this may seem unnecessary, but occasionally we find ourselves in the middle of a problem without ever having decided that we really want to solve it in the first place, or without believing that it really is a problem in need of solution. Lacking any real desire to solve the problem, we direct our creative energies toward efforts to eliminate it. If we want to bring our creativity to bear, we must want to solve the problem. What is required is an active receptivity, a willingness to "make the problem our own."

It is not uncommon in a class to be confronted with a problem that seems to be of little relevance to our particular interests or goals. Rather than resisting or rejecting the situation, it is useful to keep in mind the unique goals of the classroom situation. The class offers an opportunity to discover ideas, materials, or approaches that one might be reluctant or unlikely to explore in other circumstances.

In order to accept a problem we must first understand what the problem is. Accepting a problem is closely tied to defining it. Our solutions are to a large extent determined by the questions we ask early in the process. Problem definition involves attempting to spell out as clearly as possible what it is that we want to accomplish, taking care to make no unnecessary assumptions. It is the process of defining goals and establishing limits. Our definition of the problem determines the areas in which we will seek and find solutions.

Before beginning on a project it may be useful to ask a few questions:

What are the goals of the project; what is it intended to accomplish?

What are my goals?

What do I hope to achieve through this project?

What are the instructor's expectations?

What are the project's limits in terms of scale, materials, methods of execution, presentation, time, etc.?

Can I restate the problem in such a way that it incorporates all of these goals and limitations—the instructor's and my own?

At this point one is ready to proceed, keeping in mind that it is always possible, and often desirable, to return to this stage. As work proceeds, one's understanding of the problem is likely to change. This evolving understanding of the issues can result in a need to redefine the problem.

IDEATION

This is the part of the process that is usually associated with intellectual creativity. In this stage of the process we come up with ideas and possible solutions to the problem. The most common mistake made at this stage of the process is to judge our ideas immediately, before taking time to explore them. An idea comes to mind, and we immediately reject it as inappropriate, or decide that it won't work. At this stage our goal should be to generate as many different ideas as possible without screening them into categories of "good" and "bad." Sketching and modeling are our primary tools for this exploration.

First ideas come to mind immediately, often flowing into the sketchbook before we fully comprehend the problem. They are often followed by less promising possibilities. It is important to suspend judgment and record these ideas as well. First ideas are "obvious." That's why they spring to mind so quickly. By setting "dumb" ideas down on paper, two things are accomplished. First, these ideas may have elements that can be modified and combined to suggest a more interesting solution. Second, setting them down on paper or building models of them frees us to begin to look for "new" ideas. Exhausting obvious possibilities often allows us to move to a different area of speculation. This is not to say that a more obvious first idea will not sometimes be the best solution.

JUDGMENT

Most serious problems in creativity arise from bad judgment. This doesn't mean that the decisions and choices are in and of themselves bad. Rather, the timing is often off. We either judge too soon—during the ideation process—or too late. We tend to be either too quick or too slow to judge.

At times we are confronted with critical choices and fail to make any judgment at all, accepting what we see before us as somehow necessary. In so doing we seek to avoid responsibility for certain aspects of our work. The unwillingness to judge can result from a natural reluctance to find our work inadequate and accept the need to return to an earlier stage of the process. This is a failure of truly wanting to solve the problem. It is important to realize that going back may be more expeditious in achieving successful results than trying to repair mistakes.

Similarly it is easy to judge our work too quickly out of impatience to reach a solution or failure to take our choices seriously. Decision making is at the very core of the design process. When we stop making choices, we cease to function as artists or designers, and reduce ourselves to laborers. Design takes courage—the courage to confront what we have done and to take the risk of trying things that may not work, the courage to recognize elements of our work that are not successful and to accept the responsibility of restructuring the work until it succeeds.

Object making often involves alternating and overlapping periods of creativity and labor. Seldom will an artist or designer find himself with a good idea fully realized that only needs simple labor for its completion. Successful work requires continuing awareness of the effectiveness of our efforts in both of these areas.

3. THE ELEMENTS

Our discussion of the elements of form takes up the elements in their dimensional order, since each element is an outgrowth of the dimension that precedes it.

A point is a non-dimensional figure. It has no length, width, or depth. It occupies no space. If we imagine a point, however, moving through space in time, leaving a path behind it, that path describes a *line,* a one-dimensional figure having length but no height or depth.

Now imagine a line moving through space in time and the path it would describe. The result is a *plane,* a two-dimensional figure having length and width but no depth.

Finally, imagine a plane moving through space in time and the figure it describes. The result is a figure with length, width, and depth. This three-dimensional figure is a *volume.*

We shall look at each of these elements individually, considering their special properties and exploring ways of looking at and understanding them. Each of the elements is first defined and considered in both explicit and implicit manifestations. *Explicit form* is form that is both material and substantive. It physically occupies space. *Implicit form* is form that is immaterial but whose presence is implied by the interaction of surrounding material. While these terms, *explicit* and *implicit,* share some things with the concepts of *positive* and *negative shape* in two-dimensional design, they have a special meaning in three-dimensional design.

Although each of the elements is considered separately in our discussion, you should be aware that just as all lines have some width and all planes have some thickness (at least for our purposes), so the elements are rarely used individually by artists and designers. Our separation of them is directed at increasing our understanding of their unique properties. Line, plane, and volume are inseparable in the real world.

Figure 9. Mark di Suvero, *Achilles' Heel* (1969). Welded steel, 35″ × 40¼″ × 40″. (Collection of Whitney Museum of American Art; promised 50th anniversary gift of Mrs. Robert W. Benjamin; acq. # P.4.80; photo by Jerry L. Thompson)

Line

Line is the most basic element of form. It is the primary element in any number of expressions, such as Beverly Pepper's columns or Deborah Butterfield's horses.

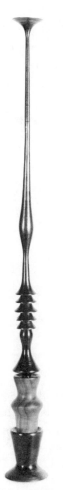

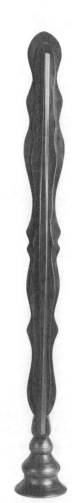

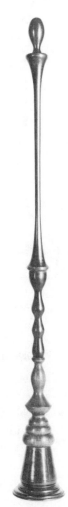

Figure 10a. Beverly Pepper, *Philemom* (1983–1984). Bronze and padouk wood, 48¾" high. (Courtesy of André Emmerich Gallery; photo by George Tatge)

Figure 10b. Beverly Pepper, *Aristo* (1983–1984). Steel, 45" high. (Courtesy of André Emmerich Gallery; photo by George Tatge)

Figure 10c. Beverly Pepper, *Gaia* (1983–1984). Bronze, steel, and bubinga, 48⅞" high. (Courtesy of André Emmerich Gallery; photo by George Tatge)

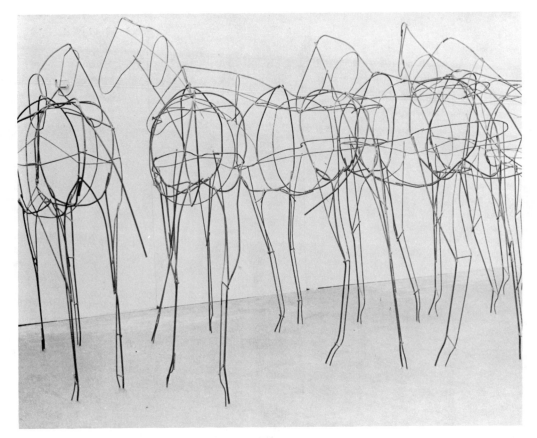

Figure 11. Deborah Butterfield, *Herd of Horses* (1976). Welded steel armature, life-size. (Courtesy of Zolla/Lieberman Gallery)

The fundamental characteristic of line is *direction*. Lines are those elements of form whose primary dimension is length. Although all lines in three-dimensional space have some width and depth, these dimensions are dominated by length. The direction of a line is traced by its primary axis. The direction is the path that the line follows.

Lines are characterized by length or direction along an axis. There are, however, many ways in which matter may be arranged to produce lines. Lines may be explicit or implicit, or a combination of both.

Explicit lines are comprised of matter aligned along an axis. The illustration of the rod, pipe, beam, rope, toothpick, and I-beams shows forms that function as explicit lines.

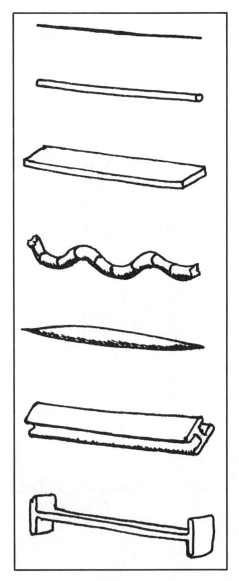

Figure 12. Explicit lines.

Implicit lines are comprised of space aligned along an axis. We see examples in the illustration of forms that create implicit lines, the result of our natural tendency to connect points in space (like a dot-to-dot drawing) and the visual momentum created by aligned form. Implicit lines may also be created by such things as incisions and interfaces.

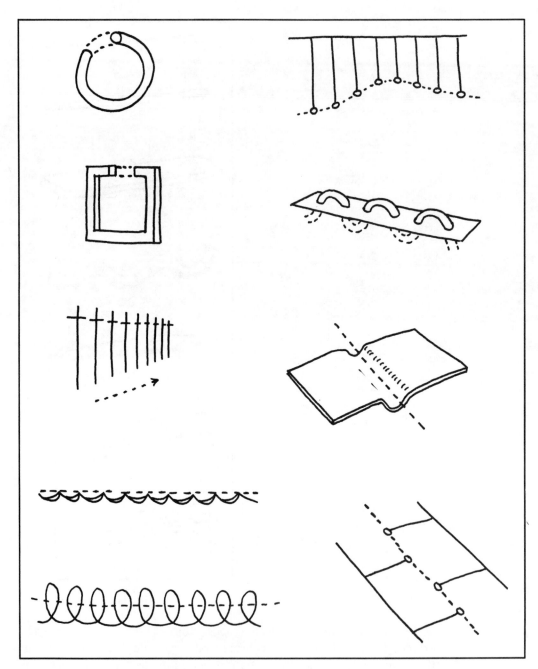

Figure 13. Implicit lines.

In Karl Ross's sculpture we are aware not only of the explicit spiralling lines of the wires, but also of the implicit lines of direction along their axes.

Figure 14. Karl J. Ross, *Untitled* (1982). Mixed media and found objects, 5½" × 5½" × 5". (Courtesy of the artist)

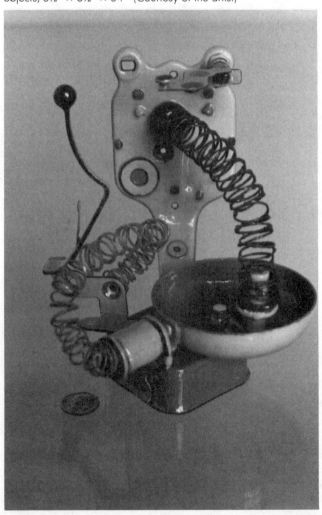

Plane

The next of the elements in our dimensional ascension, plane, is the major element at work in such diverse expressions as Anthony Caro's *Table Piece CII* and Barbara Zucker's *Morristown Red Series*.

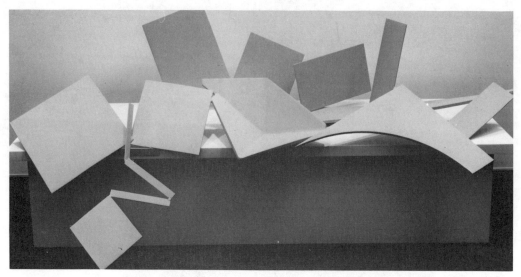

Figure 15. Anthony Caro, *Table Piece CII* (1970). Painted steel, 28″ × 79¼″ × 32½″. (Courtesy of André Emmerich Gallery; photo by Kevin Ryan)

Figure 16. Barbara Zucker, *Morristown Red Series* (1983). Painted wood, approx. 8′ high, installation view. (Courtesy of Pam Alder Gallery; photo by Pelka/Noble)

The fundamental characteristic of plane is *surface*. Planes are formal elements that have width and length. The surface of a plane may be flat and smooth, as in the Caro, or modulated, textured, and folded as in Lynda Benglis's *Andromeda*.

Figure 17. Lynda Benglis, *Andromeda* (1982). Metalized bronze mesh, 22″ × 26″ × 11¼″. (Courtesy of Fuller Goldeen Gallery)

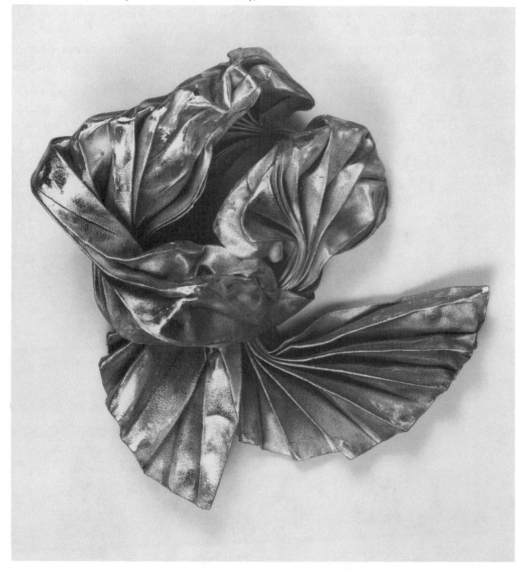

Our perception of the surface of a plane is affected by its finish—rough or smooth, flat or glossy, reflective or absorptive.

While a plane always has some depth or thickness, we are predominantly aware of it in terms of its surface. Consider the dominance of surface in a planar construction like Michael Dunbar's *River Crossing*.

In addition to surface, planes are characterized by their shapes. When we refer to a plane in terms of its shape qualities we can apply the categories that we use in talking about two-dimensional work (see illustration).

As is the case with the other elements of form, planes may be explicit or implicit. *Explicit planes* physically occupy space, while *im-*

Figure 18. Michael Dunbar, *River Crossing* (1985). Steel, 14″ × 14″ ×14½″. (Courtesy of Zaks Gallery)

Figure 19. Anthony Caro, *Carriage* (1966). Steel painted blue, 6' 5" × 6' 8" × 13'. (Courtesy of André Emmerich Gallery; photo by Geoffrey Clements)

plicit planes are the product of the interaction of other elements in their vicinity.

Implicit planes are usually the result of the interaction of lines. We are naturally inclined to connect lines that are in proximity to one another. If these lines are along side of one another, or create a closed shape, the result of this connection is often an implied plane. Explicit elements—points and lines—define implied planes.

Anthony Caro's *Carriage* uses a grid composed of linear elements that function as implicit planes. In Zucker's work linear elements also combine to form planes. The variations of density in the lines creates a gradation from implicit planes built from lines to explicit planes with holes in them.

The circular linear element in Michael Todd's *Western Moon II* creates an implicit plane within its perimeter that we see as interacting with and containing other elements in the sculpture. The plane in the Todd, while much more open than those in the Caro or the Zucker, is no less visually substantial.

Figure 20. Michael Todd, *Western Moon II* (1984). Bronze with patina, 12″ × 30″ × 25″. (Courtesy of Klein Gallery)

REGULAR SHAPES

IRREGULAR SHAPES

AMORPHOUS OR
ORGANIC SHAPES

BROKEN SHAPES

CUT SHAPES

COMPLEX SHAPES

PIERCED OR
PERFORATED SHAPES

REFERENTIAL SHAPES

DISTORTED SHAPES

CURVILINEAR SHAPES

Figure 21. Types of shapes.

Volume

Last in our consideration of the elements is volume. Volume, fully real-ized three-dimensional form, is that element we are most used to asso-ciating with dimensional expression. It is the dominant element at work in such diverse objects as Roger Blakley's "g" and Ron Nagle's *Blue Shooboat.*

The dominant characteristic of volume is that it occupies space. While it is possible to relate to lines and planes as one- or two-dimen-sional, that is, lacking substance or depth, volumes always occupy space.

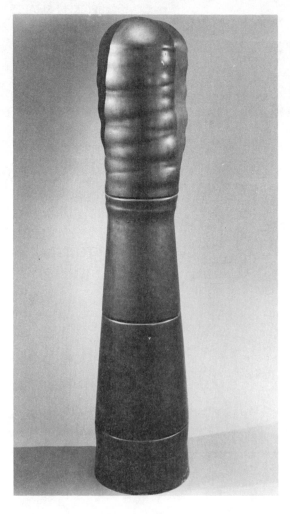

Figure 22. Roger Blakley, "g" (1974). Cast bronze, 6' × 15" × 16". (Courtesy of Nina Owen Ltd.; photo by David Frej)

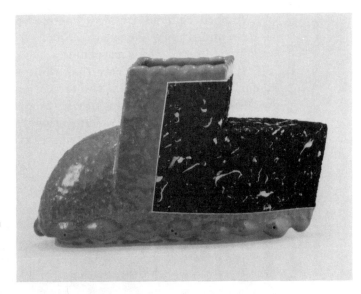

Figure 23. Ron Nagle, *Blue Shooboat* (1984). Ceramic, 2⅛″ × 3⅜″ ×1¼″. (Courtesy of Rena Bransten Gallery; photo by M. Lee Fatherree)

Volume also, like line and plane, may be explicit or implicit. Implicit volume is defined by the interaction of the elements of form.

Lines and planes imply volumes by delineating the boundaries or surface of space. Consider Deborah Butterfield's *Rondo*. The network of linear elements combine to create implicit planes, which in turn work together to imply a substantial implicit volume.

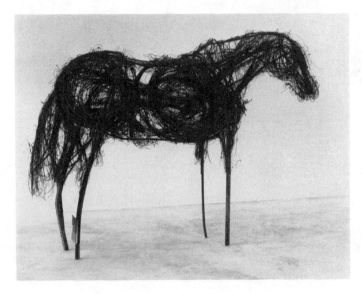

Figure 24. Deborah Butterfield, *Rondo* (1981). Metal and wood, 76″ × 104″ × 40″. (Courtesy of Fuller Goldeen Gallery)

Implicit volumes are also generated by explicit volumes. This can be seen in Arnaldo Pomodoro's *Sfera No. 2*, where we perceive the broken volumetric forms as spheres.

It is interesting to note that while volume is fully three-dimensional, we often relate to it in two-dimensional terms. Our response to the Nagle is conditioned as much by its profile as by its overall form. The language used to describe two-dimensional shape (see Figure 21) can still be useful when discussing the attributes of volumetric form.

Figure 25. Arnaldo Pomodoro, *Sfera No. 2* (1963). Bronze, 100 cm diameter. (Courtesy of Wirtz Gallery; photo by Fotografia Francesco Radino, Milan, Italy)

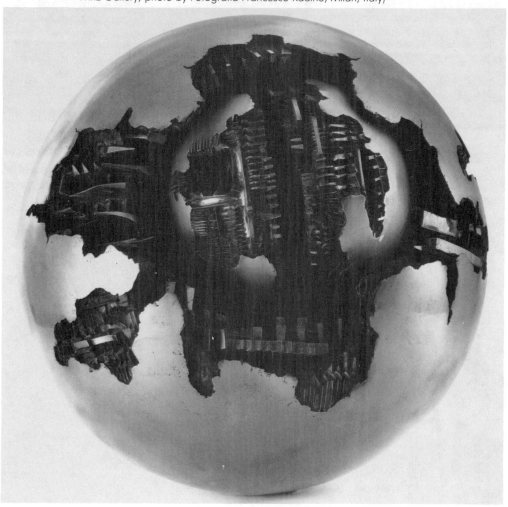

In Combination

Don Potts's *Soap Box Derby Car* shows all three elements of form—line, plane, and volume—working in concert. The spoked wheels form implicit planes. The explicit lines and curved plane of the central form combine to create an implicit volume. The curving horizontal explicit lines unite with the implicit volume to create a single centered implicit line along the major axis of the piece.

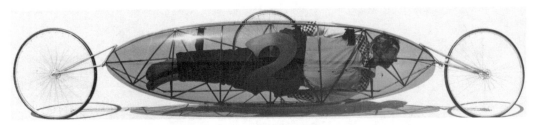

Figure 26. Don Potts, *Soap Box Derby Car* (1975). (Courtesy of Fuller Goldeen Gallery; photo by Steve Kiser)

Figure 27. Don Potts, *Soap Box Derby Car* (1975). (Courtesy of Fuller Goldeen Gallery; photo by Steve Kiser)

4. THE ATTRIBUTES OF FORM

Understanding form requires more than simply recognizing it as linear, planar, volumetric, or some combination of the three. Formal elements have attributes that affect their function in space and our responses to them—both visually and intellectually.

In this chapter we discuss some of these attributes and the ways in which they interact with the elements. Our discussion begins with *mass*—ways in which forms assume visual weight. We then deal with *radiation* and *perceived movement*—ways in which individual formal elements command the space around them and ways in which our visual attention is directed through that space. Finally, we take up *gesture*—ways in which the elements assume expressive character.

Figure 28. Roy De Forest, *Untitled* (1983). Mixed media (wall piece), 110″ × 66″ × 16″. (Courtesy of Fuller Goldeen Gallery; photo by M. Lee Fatherree)

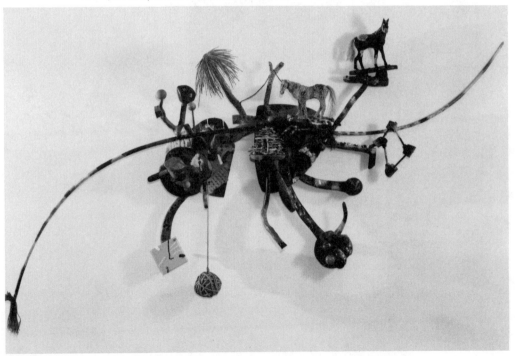

Mass

The perceived mass of a form is dependent upon a range of factors under the control of the artist. Factors that affect our perception of mass are density, value, material, and spatial orientation.

Visual density, or compactness, is one of the first cues of mass. The greater the density of matter in a form the more mass it will be seen to

Figure 29. Stephen De Staebler, *Wedged Man Standing II* (1981–1982). Bronze with oil-based pigment, 88″ × 17″ × 25″. (Courtesy of John Berggruen Gallery; photo by M. Lee Fatherree)

have. Stephen De Staebler's *Wedged Man Standing II* gains much of its quality of massiveness from the compactness of its form. Compare this to the more airy quality of Charles Arnoldi's *CHA 1106 Scorpion*. While the material used in the Arnoldi (bronze) has considerable physical mass, the openness of the form suggests lightness. De Staebler, on the other hand, reinforces the compactness of his material, "wedging" it together.

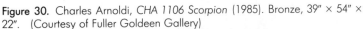

Figure 30. Charles Arnoldi, *CHA 1106 Scorpion* (1985). Bronze, 39″ × 54″ × 22″. (Courtesy of Fuller Goldeen Gallery)

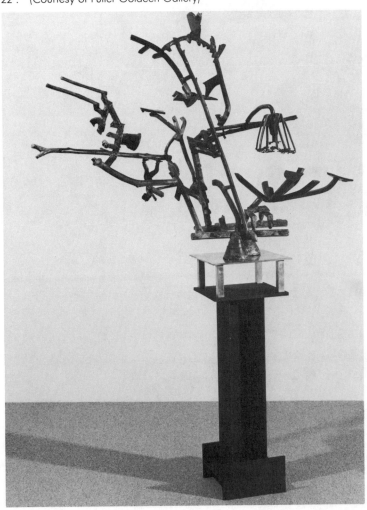

Value—that is, the relative lightness or darkness of form—is another major determinant of its perceived mass. This is demonstrated in *Hercules* by Zigi Ben-Haim. Imagine how much more improbable this piece would seem with the values reversed, that is, with the dark form supported by the light form.

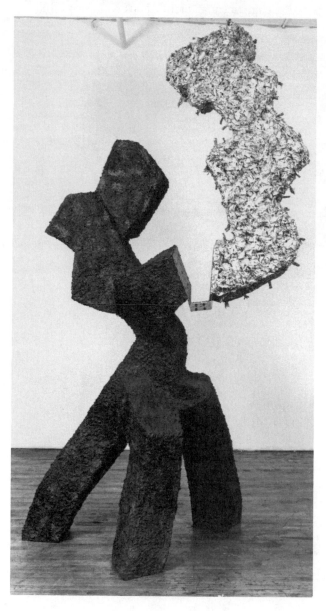

Figure 31. Zigi Ben-Haim, *Hercules* (1984). Wire mesh, steel, newsprint, and oil, 117″ × 66″ × 44″. (Courtesy of the artist)

We bring to our encounter with form certain knowledge of the characteristics of material, and this knowledge also affects our perception of mass. H. C. Westermann's *Birds = Eye Maple Snake House* is every bit as compact as Eduardo Chillida's *Cross*, but as we know steel to be much more massive than wood, we perceive the Westermann as less massive.

Figure 32. H. C. Westermann, *Birds = Eye Maple Snake House* (1976). 15½" × 9⅞" × 12". (Courtesy of John Berggruen Gallery; photo by M. Lee Fatherree)

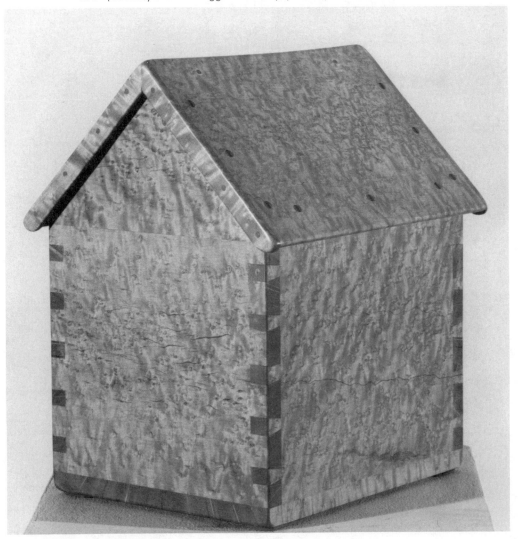

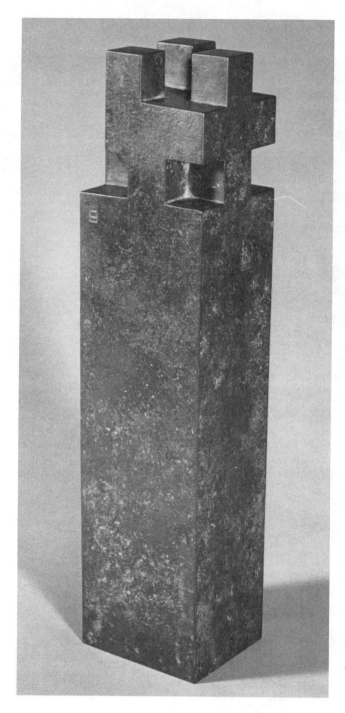

Figure 33. Eduardo Chillida, *Cross* (1983). Steel, 17¼" high. (Courtesy of Tasende Gallery)

Pipeline, by Bob Clore, presents us with a range of strategies for dealing with perceived mass. The dark horizontal cylinder denies its mass by appearing to float through the three vertical rings. The vertical column establishes a contrast between a feeling of density at its juncture with the horizontal form at the base and the perceived lightness that results from its taut, swollen appearance and light value.

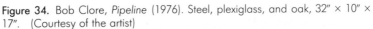

Figure 34. Bob Clore, *Pipeline* (1976). Steel, plexiglass, and oak, 32″ × 10″ × 17″. (Courtesy of the artist)

Finally, the spatial orientation of a form indicates mass by referring us to gravity. Consider the range of masses in the forms in Isamu Noguchi's *Sunken Courtyard*. The horizontal pyramid flattening out upon the ground is much more massive in character than the doughnutlike form resting on its edge, or the cube balanced on a corner, although all three forms are of the same material, value, and approximate density.

Figure 35a. Isamu Noguchi, *Sunken Courtyard*. Beinecke Library, Yale University. (Courtesy of Office of Public Information, Yale University; photo by T. Charles Erickson)

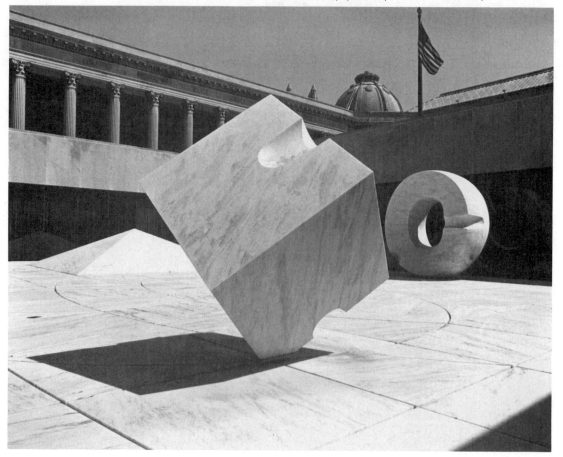

Figure 35b. Isamu Noguchi, *Sunken Courtyard*. Beinecke Library, Yale University. (Courtesy of Office of Public Information, Yale University; photo by T. Charles Erickson)

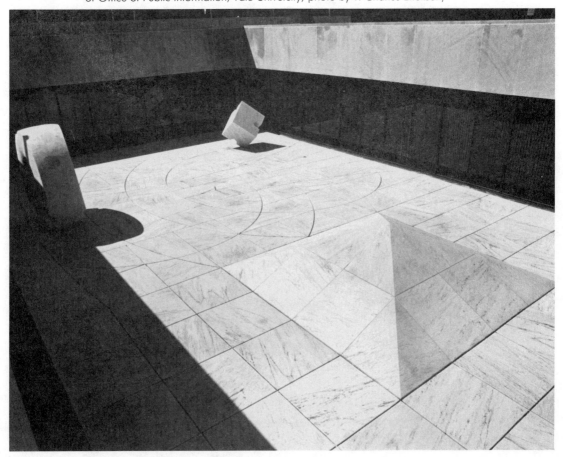

Radiation and Perceived Movement

Form is not limited to the space that it physically occupies. Forms project or radiate beyond their physical boundaries, activating the space that surrounds them. Form not only exerts its influence on the space around it but also actively controls the ways in which we as viewers "move through" an object by creating barriers or pathways for the mind's eye.

Figure 36. Gerald Walburg, *Landscape Series #1* (1982). Steel, 2' × 3' × 6' 9". (Courtesy of the artist)

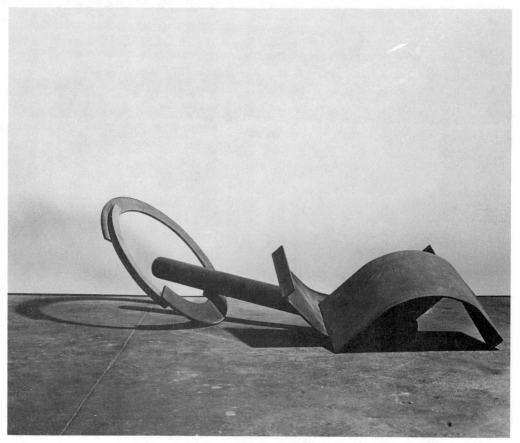

IN LINES

As a line moves through space it can gain momentum, and our response to it may give us an awareness of its extending along its axis beyond its physical end. This projection of length by lines is controlled by the perceived speed of the line, which is in turn responsive to the orientation and texture of the line. Uniform or evenly modulated lines acquire more speed than do rough and irregular lines. Descending lines have more speed than do ascending or horizontal lines.

In addition, projection is dependent on the termination of the line. A line with an abrupt or ragged end, appearing cut or broken, may project more powerfully than a line with a tapered or rounded end. A line with a tapered end narrows to a specific point in space, while a more abruptly terminated line may appear broken or cut, reminding us of the material that was "removed."

Lines function as tracks, pulling us along their lengths. They are potentially the strongest directional cues, guiding us forcefully along their axes.

In Mark di Suvero's *Homage to Charlie Parker* we see line that projects strongly, unimpeded by changes in width or disruption of surface. The beams are supported both structurally and visually by the taut cables.

Figure 37. Mark di Suvero, *Homage to Charlie Parker* (1970s). Steel and wood, 13' 3" × 35' 8" × 21'. (Collection of the Oakland Museum; courtesy of John Berggruen Gallery; photo by M. Lee Fatherree)

Energetic linear shapes in Michael Todd's *ENSO #29* extend physically beyond the limits of the defining circle, but their visual activity is contained within it. The sweep of the containing circle is intercepted by the smaller linear elements, and while the movement around it is never stopped, it is moderated by their action.

Figure 38. Michael Todd, *ENSO #29* (1984). Bronze, 30″ × 26″ × 12″. (Courtesy of Klein Gallery)

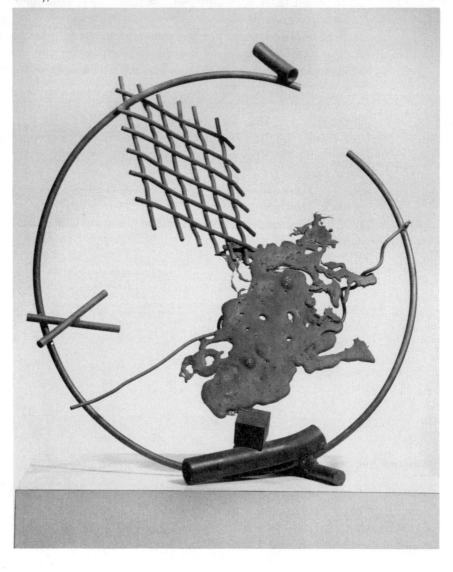

The tower in Westermann's *The Wild Man from Borneo* is capped and contained by the cube resting on its top. The winding tube moves without interruption toward an implicit confrontation with the head. The horizontal repetition of the laminated plywood provides a sense of stability, which contrasts with numerous visual clues that suggest impending events.

Figure 39. H. C. Westermann, *The Wild Man from Borneo* (1977). Wood and copper construction, 45″ × 37½″ × 12¼″. (Courtesy of John Berggruen Gallery; photo by M. Lee Fatherree)

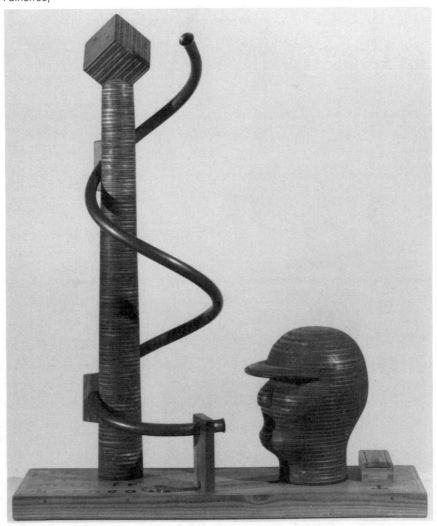

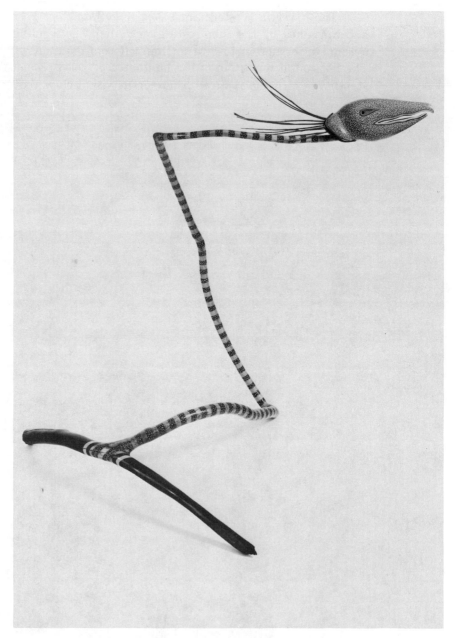

Figure 40. Thomas Golya, *Bird in Transcendence* (1981). Grapevine, wood, and enamel, 54″ × 41″ × 53″. (Courtesy of Zolla/Lieberman Gallery)

IN PLANES

The surface of a plane not only defines it but also may be a source of its radiant energy. Just as lines may project themselves beyond their physical dimensions, so planes may activate a field beyond their surfaces. This field may be thought of as a layer of space lying on the surface of the plane, like icing on a cake, but felt to be part of the space physically occupied by the plane.

This radiation is strongest when planes are parallel to other planes in the piece or to the ground (a limitless plane). It is responsive to gravity, extending further below a horizontal plane than above it. It is also responsive to the scale of the plane. Planes that are extremely large or small radiate proportionately less than planes of "middle" scale.

Additionally, it is responsive to surface quality. Radiation is greater when surfaces are uniform: smooth, dark, or nonreflective. It is diminished when they are irregular: roughly textured, high in value, transparent, or reflective. Warm hues and high intensity colors tend to exert a greater radiative force than do cool hues and low intensity colors. The more uniform a surface is, the greater its radiative reach; the more variegated it is, the shallower its field.

When confronted with planes in a piece, we move visually along their surfaces. If the planes are longer than they are wide, the movement is primarily along the length of the planes, and they function in many of the same ways as do lines. The sides of a form such as an I-beam can serve as rails, further directing our movement through the piece. For example, consider an I-beam that is taller than it is wide, suggesting a vertical direction: If the sides of the beam are horizontal, we may be inclined to move parallel to them in that area.

Figure 41. Vertical and horizontal I-beams.

If the planes are less directional in shape, we are more inclined to move about their surfaces randomly, coming to rest here and there and then jumping to another surface.

In addition to being controlled by shape, movement through a piece is responsive to the orientation of the planes in space. Horizontal planes are more likely to function as pathways. They "support" our movement across their surfaces. When confronted with a plane placed at an angle to the ground the eye is more inclined to "slip off" its surface. Vertical

Figure 42. Radiation and planes.

planes function most strongly as barriers, stopping our movement through, and forcing us to "go around." Caro's table piece (Figure 15) demonstrates this elegantly.

We are confronted with a barrierlike plane in Sam Richardson's *Wedge on Horse*. The plane's verticality draws our attention to its surface. In Edward McCullough's *Station I* the tilted planar elements interact forcefully with one another and the space below them. The tilted plane in Jeremy Anderson's *Toys of a Prince* creates a sense of potential energy.

Figure 43. Edward McCullough, *Station I* (1980). Cor-ten steel, 20″ × 30″ × 23″. (Permanent collection: University of Iowa Museum of Art; courtesy of Zaks Gallery)

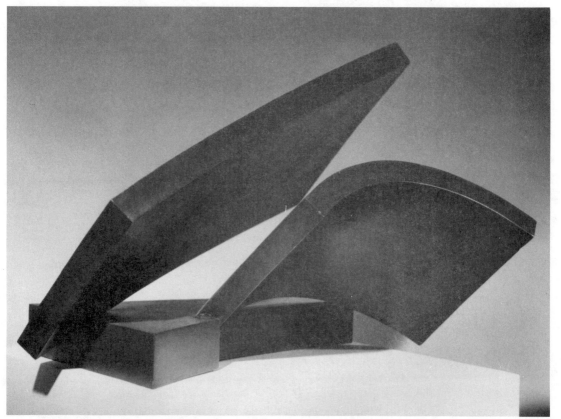

Figure 44. Sam Richardson, *Wedge on Horse* (1984). Acrylic on paper on wood, 74″ × 43″ × 18″. (Courtesy of Klein Gallery; photo by M. Lee Fatherree)

Figure 45 (below). Jeremy Anderson, *Toys of a Prince* (1965; after G. deChirico, 1914). Mixed media, 39″ × 95″ × 45½″. (Courtesy of Braunstein Gallery; photo by Phillip Gauga)

IN VOLUMES

Just as lines may project, or planes radiate, beyond their physical limits, so volumes also project beyond their physical limits, defining and activating space beyond themselves, suggesting an envelope that contains their major components.

A major source for the radiative power of form is our perceptual desire to simplify forms in order to understand them more easily. For example, we perceive the cubic form in Noguchi's *Sunken Courtyard* (Figure 35) as a cube with cuts taken out of it, and to the toroid form as a penetrated disk with similar cuts.

It is this desire to see forms as simply as possible that inclines us to enclose any volume in a sensed envelope containing its major components.

Volumes seems to control our movement most powerfully when they are implicit rather than explicit. Our attention is easily drawn to the cylindrical volume implied by the hole in Isamu Noguchi's *Variations on a Millstone #1*. The fact that this hole is a singular feature in a larger expanse adds to its visual importance.

Figure 46. Isamu Noguchi, *Variations on a Millstone #1* (1962). Granite, 24⅝" d. × 4" on a pedestal. (Collection of Whitney Museum of American Art; 50th anniversary gift of Mrs. Robert M. Benjamin; acq. # 86.1; photo by Jerry L. Thompson)

Gesture

The final attribute of form we are exploring here is gesture. Just as we talk about gesture in drawings and paintings, so it is also evident in three-dimensional expression. We use words like gentle, flowing, bold, aggressive, authoritative, sensuous, agitated, serene, or humorous to describe gesture. It is the expressive and evocative qualities of form that we refer to when we talk about gesture.

In three-dimensional work, as in drawing, gesture is usually associated with the human form. Line is often the major element of gesture. The gesture of linear form results from the quality or nature of the line, and is generated by the line's physical characteristics—its thickness, surface, and direction—and by its reminding us of known or remembered form or movement.

The gestural character of planes or volumes is largely dependent upon the referential qualities of their shapes and surfaces.

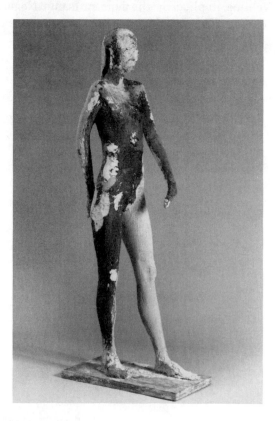

Figure 47. Manuel Neri, *Niña Clavada II* (1984). Plaster, dry pigment/water, 68½" × 16" × 26". (Courtesy of John Berggruen Gallery; photo by M. Lee Fatherree)

Figure 48. Richard Shaw, *Two Figures on a Stand* (1984). Porcelain with decal overglaze, 26½" × 17½" × 9". (Courtesy of Braunstein Gallery)

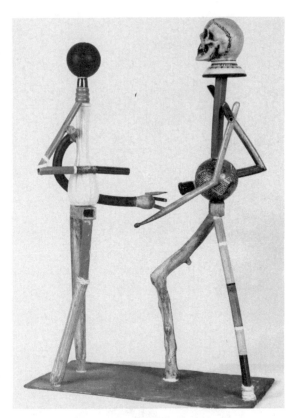

Figure 49 (below). Deborah Butterfield, *Rosary* (1981). Metal and wood, 32" × 100" × 58". (Courtesy of Fuller Goldeen Gallery)

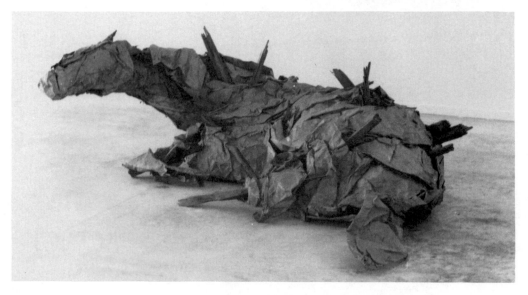

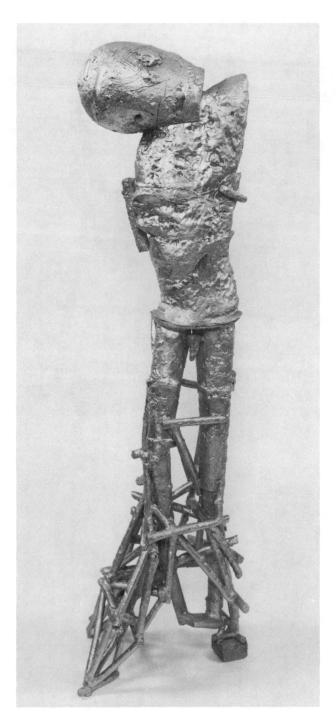

Figure 50. Robert Brady, *Descendant of I. O.* (1984). Stoneware and glaze, 64" × 17½" × 7". (Courtesy of Braunstein Gallery; photo by White Line Photography)

Figure 51. Tom Rippon, *S'Tachoo* (1981). Porcelain, 35″ × 14″ ×10″. (Courtesy of Rena Bransten Gallery)

5. ORGANIZATION

It is the organization of form that distinguishes the work of the artist or designer. The decisions made in organizing the formal elements at our command determine the visual structure of our final products and dictate the responses they will generate. If our work is to be successful, it is necessary that we understand the principles governing those responses as fully as possible. Response to form is conditioned by the ways in which it is perceived. To control that response, it is necessary for us to focus our attention on the principles that guide it.

Our consideration of the organization of form is broken into four parts. We first consider *perception*—the ways the human mind understands the information provided by our senses. This determines to a large extent what it is that we see.

Next, we consider *physical forces*—those forces that relate to physical reality and give special significance to the orientation of the elements of form in relation to the ground plane.

Finally, we turn to *rhythm*—ways in which the intervals in a piece can influence our response to the piece—and *time* and *process* as additional organizational forces.

Perception—Grouping

Underlying any understanding of perception must come the realization that what we see are *differences,* or *contrasts.* This means that we define the quality of one part of our perceptual field by comparing it to the rest of the field. Without contrasts our perceptual field would be flat, neutral, incomprehensible. A leopard's spots stand out in contrast to the coloring of the rest of its skin. A panther's spots are invisible.

An old but relevant cliché says that "nature abhors a vacuum." By the same token, the mind abhors a void. The more subtle the contrasts, the more finely we tune our perceptions. We have a fundamental need to make sense of our world, and the perception of contrasts is essential to the fulfillment of that need. Experiments in sensory deprivation in which subjects are immersed in an environment totally devoid of contrasts demonstrate this. Within a very short period of time subjects of these experiments show signs of serious disorientation. It is this need to make sense of the world around us that causes us to seek out, and attend to, the contrasts within a work.

When we look at the world around us, we process the incoming information, filtering out that which we deem insignificant, focusing on that which is of special interest to us. This focusing of attention is necessitated by the enormous amount of sensory information available to us. Our senses bring in much more than we are able to deal with. In response, we attempt to simplify the information, to put it into a form that we can digest.

This simplification takes many forms and goes on without our being aware of it. What the mind attempts to do is to find simple models for understanding various aspects of form, grouping the parts into larger constructs that can be more readily handled. As you read this page you are not aware of all the individual letters. You immediately group them in your mind into words and phrases.

There is a limit to the number of distinct elements that we are able to attend to at any given time. This can be demonstrated by a simple pattern recognition test. If a coin is thrown out on a table and you are asked, "How many?" you see one. You don't have to count. Similarly we are all able to recognize a group of two or three. At some point, however, and it will vary from individual to individual, you will begin mentally to break the coins into smaller groups. For most people, this cutoff point comes at around five. Not readily able to see five coins as a group of five,

Figure 52. Seymour Lipton, *Sorcerer* (1957). Nickel-silver on Monel metal, 60¾" × 36" × 25". (Collection of Whitney Museum of American Art; purchase, with funds from the Friends of the Whitney Museum of American Art; acq. #58.25; photo by Geoffrey Clements)

we are likely to see a group of three associated with a group of two. Eventually the groupings will become too complex for immediate recognition and we will be forced to count the coins.

We deal with the problem of visual complexity by grouping elements together into manageable sets. Much study has been done of the ways in which we do this grouping, and the principles that underlie *selective vision.* We try to create the simplest sets possible for initial understanding. To go back to the coins on the table, for example, we might break down our visual field into two sets—the table, and the coins. Everything else is pushed into the background to allow us to attend to the problem at hand.

The choices we make in forming these sets are determined by a number of principles. Our primary motivation is to make sense of what we see. Among the principles that have great importance to us as artists are *resemblance, proximity,* and *similarity.*

RESEMBLANCE

"What is it?" This is often the first question we want answered when looking at an object. The answer generally comes in the form "It looks like . . . ," or "It reminds me of" We seek a resemblance between the forms as organized and known objects or forms, in addition to the recognition of the physical nature of the forms themselves.

Figure 53. Manuel Neri, *Untitled Standing Figure No. 6* (1981). Plaster, 65″ × 24″ × 18″. (Courtesy of John Berggruen Gallery)

We can see this principle at work in comparing our response to works by Manuel Neri, Deborah Butterfield, and Robert Hudson. Neri's figure and Butterfield's horse are both recognized immediately. Knowing "what they are" frees us to explore the complexities of surface, gesture, and material. In the case of the horse, we are also aware of the contrast and tension between what the piece appears to be (a horse) and what we know it to be (an agglomeration of wood and metal).

Figure 54. Deborah Butterfield, *Palomino* (1981). Metal and wood, 76″ × 97″ × 50″. (Courtesy of Fuller Goldeen Gallery)

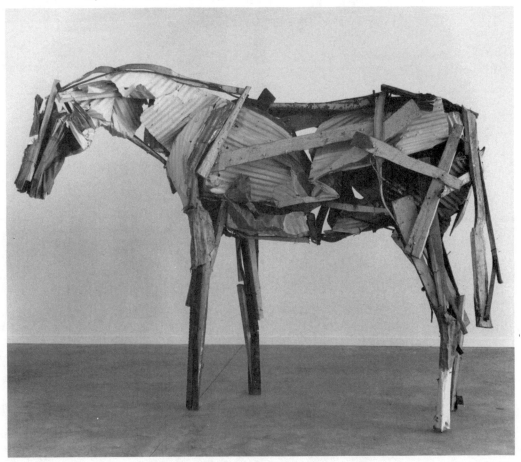

Hudson's *Plomb Bob* confronts the viewer with a complex array of disparate forms. In our desire to make sense of it we almost immediately recognize a figure, which unifies the piece and allows us to begin to explore its complexity.

Figure 55. Robert Hudson, *Plomb Bob* (1982). Steel/paint, 103½″ × 86″ × 72″. (Courtesy of Fuller Goldeen Gallery)

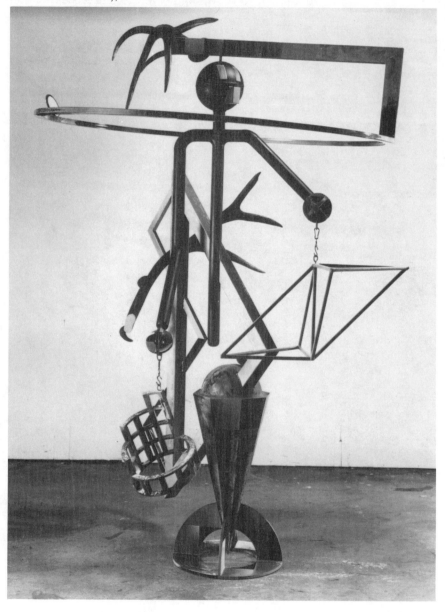

PROXIMITY

A piece like Tony Hepburn's *Chicago Analog* does not readily yield an answer to our query "What is it?" It lacks specific resemblance to anything in our experience. In order to fulfill our need to make sense of the work if we are not to dismiss it, we look for internal contrasts. We seek to relate the piece to itself. If an artist's work is strong enough it can create its own universe, defining for itself what is acceptable and what is not.

We readily break the form into three parts, two vertical columns supporting a horizontal form. Each of the three major elements is composed of numerous distinct parts, but the proximity and directional alignment of the parts serve to unify and group into a simpler whole.

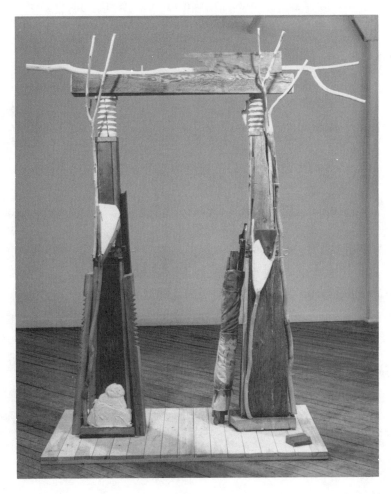

Figure 56. Tony Hepburn, *Chicago Analog* (1983). Wood, slate, clay, and canvas, 82″ × 59″ × 35″. (Courtesy of Klein Gallery)

SIMILARITY

Another key for grouping the parts of a piece is by similarity. As we look at George Sugarman's *Bardana* the search for meaning immediately leads us to connect objects of similar shape, value, character, etc., building a unifying web of relationships across the space. It is the use of repetition that holds these parts together.

The mobiles of Alexander Calder make use of the principle of similarity to create a sense of unity and a basis for understanding. His mobiles are composed of similarly shaped planes separated by linear elements that echo the contours of the planes. Variety is introduced into the pieces by the use of color on the planes, by the occasional occurrence of a plane with a contrasting shape, and by the gentle, continuous movement of the pieces. As the planes shift in a Calder mobile, changing their spatial relationships to one another, we are continuously grouping and regrouping them in response to their changing proximity.

Figure 57. George Sugarman, *Bardana* (1962–1963). Painted laminated wood, 96″ × 144″ × 62″. (Courtesy of Gallery Renée Ziegler, Zurich; photo by John A. Ferrari)

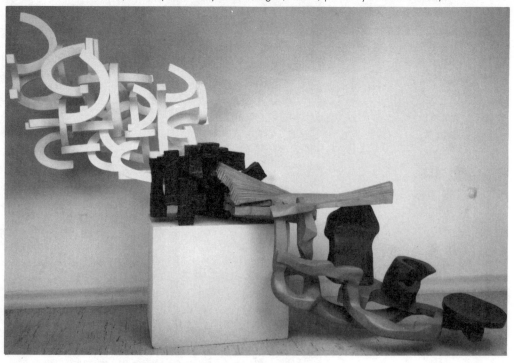

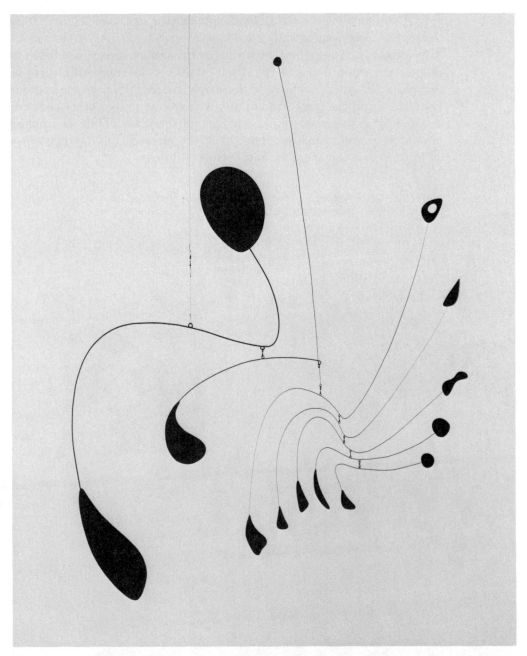

Figure 58. Alexander Calder, *Hanging Spider* (c. 1940). Painted sheet metal and wire, 49½″ × 35½″. (Collection of Whitney Museum of American Art; Mrs. John B. Putnam Bequest; acq. #84.41; photo by Geoffrey Clements)

Upon viewing a piece as seemingly chaotic as David Wiener's *Just Intonation,* our need to unify and simplify leads us to connect the repetitive elements. We are first drawn to the linear elements, which begin to suggest direction and echo the linear quality of the supporting wires in the piece. We are next drawn to the striped planes, which create another pattern within the piece. And finally we move on to seek other patterns created by elements of similar surface and character. While existing as a relatively simple and complete shape, the piece creates a strong sense of tension between these various groups of forms.

Figure 59. Daniel Wiener, *Just Intonation* (1982). Mixed media and found objects, 7′ × 8′ × 3′. (Courtesy of Stephen Wirtz Gallery; photo by Bill Jacobson)

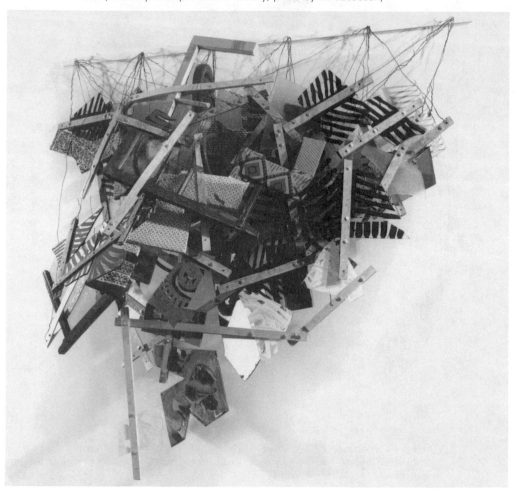

Physical Forces

We bring to our encounters with objects a basic sense of geometry dependent on our inner awareness of the ubiquitous presence of gravity. We are intuitively able to judge the correctness of a horizontal or vertical line. You do not need a level to straighten the pictures in a room, and you feel uneasy if it is not possible to straighten them.

Variations from the expected in terms of structure catch our attention. Surely the Tower of Pisa is well known more for its tilt than for its inherent architectural form. Compare the difference in the way we respond to a simple cube by Noguchi and to Tony Smith's *Die*. The major difference between the two objects is their orientation to the ground plane. The Smith, aligned squarely with the ground, allows us to deal exclusively with the object itself—its physicality. By setting a cube on its corner, Noguchi (Figure 35), while still creating a quiet and contemplative work, forces us to deal with the dynamic qualities of elevated mass.

Figure 60. Tony Smith, *Die* (1962). Steel, 6' × 6' × 6'. (Courtesy of Paula Cooper Gallery; photo by Geoffrey Clements)

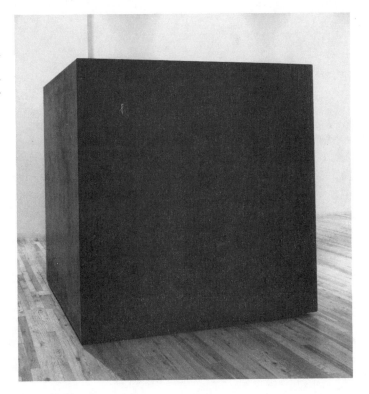

Elementary physics teaches us that when we elevate a mass above the ground—working against gravity—it acquires *potential energy*. The same principle may be applied to dimensional design. When mass is elevated in a piece it acquires a visual energy directly related to our awareness of its potential for falling. Consider Robert Hudson's *Blue E7*. If forms become too radical in their defiance of gravity, they create within us an enormous sense of unease.

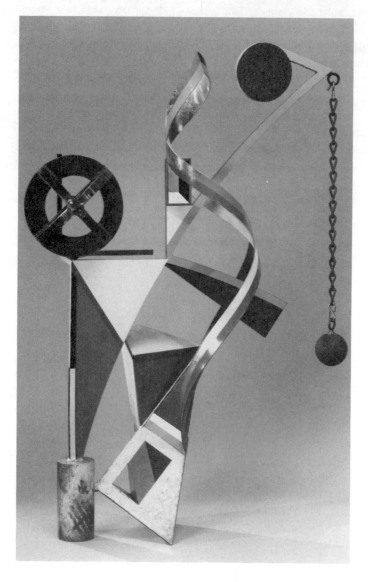

Figure 61. Robert Hudson, *Blue E7* (1982). Painted steel, 45" × 31" × 20". (Courtesy of Fuller Goldeen Gallery)

In viewing Stephen De Staebler's work we perceive two pieces interacting with gravity in differing ways. *Left-sided Figure Standing* appears to be resisting gravity; this creates a strong sense of potential energy. *Wedged Man Standing I* is in the process of succumbing to gravity's pull.

While the structure of the Noguchi is unexpected—cubes normally rest on their faces—he still presents us with a believable structure.

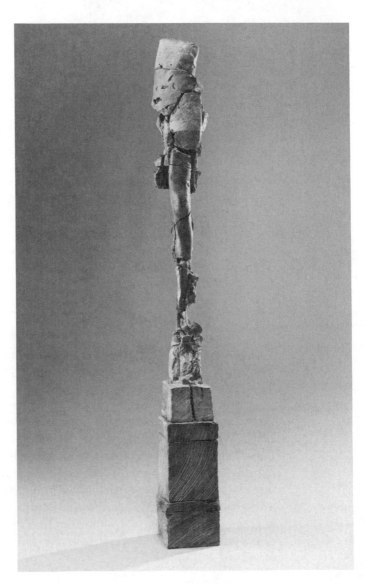

Figure 62. Stephen De Staebler, *Left-sided Figure Standing* (1981–1982). Bronze with oil-based pigment, 76″ × 9″ × 9″. (Courtesy of John Berggruen Gallery; photo by M. Lee Fatherree)

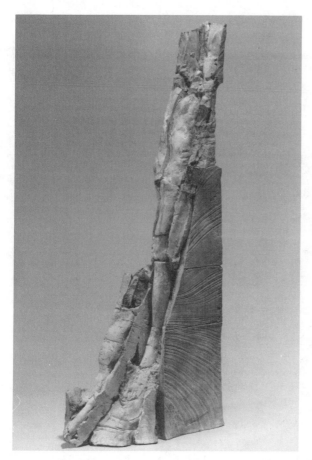

Figure 63. Stephen De Staebler, *Wedged Man Standing I* (1981–1982). Bronze with oil-based pigment, 71" × 12" × 29". (Courtesy of John Berggruen Gallery; photo by M. Lee Fatherree)

Unexpected structure can be carried even further, as in the work of Zigi Ben-Haim (Figure 31), where we are confronted with a highly improbable structure.

Our definition of "expected structure" is not static, but rather grows and changes with our experience and knowledge. When Frank Lloyd Wright first cantilevered the balconies on his homes, the buildings were perceived as daringly dynamic, defying our intuitive sense of appropriate engineering. In the last half century we have become more familiar with modern construction materials and the forms that they allow; consequently, we see these buildings as elegant but not magically supported. As we become more familiar with structures designed for gravity-free environments, it is likely that our definitions of expected structure will broaden even further.

Our internal sense of vertical and horizontal extends to angles as well. Many angles recur frequently in our everyday lives and are readily accepted. Angles that vary from these can create a sense of unease in a piece. Compare the effect of the shallow horizontal angle of the Middlebrook with the almost vertical angle of the Peter Charles piece or the intermediate angle in Gerald Walburg's *Landscape Series #2*.

Forms that approximate, but miss, alignment with these physical axes are unsettling, capturing the attention of the viewer. Violations of the expected can be used to draw attention to certain aspects of an object, but care must be taken to reinforce these gestures so that they clearly appear intentional. Otherwise we run the risk of having our work appear to be poorly thought out or accidental.

The importance of these physical forces to us as artists is that they define a universe within which we may freely work.

Figure 64. David Middlebrook, *Interface* (1984). Brazilian granite, brown travertine, cor-ten steel, and bronze, 26½″ × 23″ × 5″. (Courtesy of Klein Gallery)

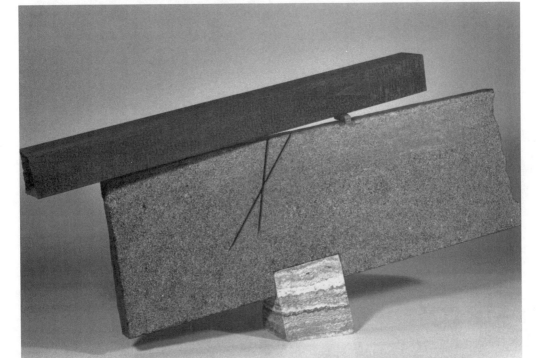

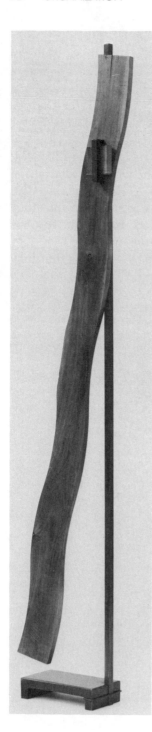

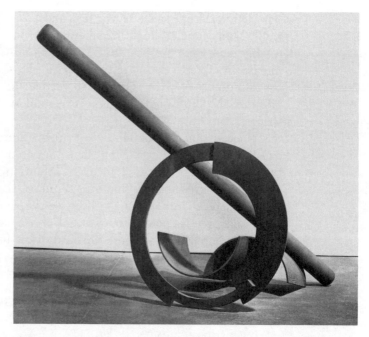

Figure 65. Gerald Walburg, *Landscape Series #2* (1982). Steel, 4' 4" × 6' × 3' 4". (Courtesy of the artist)

Figure 66. Peter Charles, *Untitled* (1982). Steel and cherry wood, 8' high. (Courtesy of Zolla/Lieberman Gallery)

Rhythm

In looking at various elements of an object we become aware of the intervals that separate them. These intervals are the source of rhythm within the work. Rhythm has specific meanings in the world of music and it may be useful to explore those meanings here.

Rhythm is the result of our sensing the repetition of regular intervals between beats. For a rhythm to be established, a series of events is required and must repeat itself in a recognizable pattern. While rhythm is dependent upon repetition, it need not be static. In objects, as in music, rhythms may change in complexity. Different rhythms may also exist simultaneously.

The regular intervals that result from the contours in Roger Blakley's *TR-21* establish a rhythm varied by the occasional occurrence of wider intervals.

Figure 67. Roger Blakley, *TR-21* (1981). Cast bronze, 8′ 2″ × 24″ × 24″. (Courtesy of Nina Owen Ltd.; photo by David Frej)

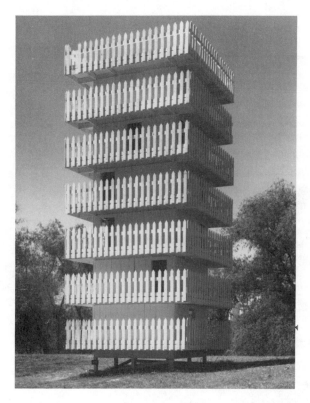

Figure 68. Alice Aycock, *The Hundred Small Rooms* (1984). Houston, Texas. (Courtesy of Klein Gallery)

The Hundred Small Rooms by Alice Aycock establishes three strong rhythms, as shown in the accompanying illustration. The dominant rhythm created by the repeated horizontal levels is reinforced by the staccato of pickets, and both combine to contrast with the background pattern created by the openings.

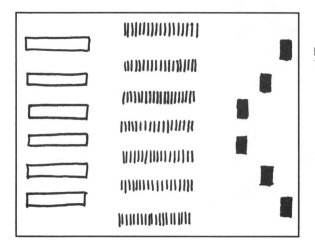

Figure 69. Rhythms in Alice Aycock's *The Hundred Small Rooms.*

Christine Bourdette presents us with a variety of rhythms in her piece, *It's a Jungle Out There*. The variation in density of the spiky protrusions on the vertical planes creates a gradation that contrasts with the regularity of other rhythms in the piece.

Figure 70. Christine Bourdette, *It's a Jungle Out There* (1981). Paint, wood, and paper, 10″ × 23″ × 13″, exterior view. (Courtesy of Klein Gallery)

Time and Process

Artists often allude to the notion of time in their work. Something appears to have happened, be happening, or be about to happen. While a kinetic piece such as Jean Tinguely's *Crown-Jacket* or Alice Aycock's *The Solar Wind* is able to depict motion literally, thereby changing various aspects of itself through time, work that is functionally static often also deals with time, process, and motion.

Figure 71. Jean Tinguely, *Crown-Jacket* (1960). Mixed media with motor, 101 cm × 58 cm. (Courtesy of Galerie Renée Ziegler, Zurich)

Figure 72. Alice Aycock, *The Solar Wind* (model) (1982–1983). Steel, aluminum, and neon—motorized, 34″ × 54″ × 48″. (Project for Roanoke College; courtesy of Klein Gallery)

Elin Elisofon's *Coyote and Case* depicts past events and process. By binding and wrapping the form, she makes visual reference to mummification. Robert Arneson deals with time in a different way in his *Sinking Brick Plates*. He creates a single illusory event by presenting us with a sequence of steps showing the progressive disappearance of a brick into a plate. Rigid materials often require the artist to create an "illusion" of the act, while more plastic media allow for the direct creation of the event. That is, an artist may create a tear by literally tearing the material or may literally show the impact of a hand or tool against a yielding material. Someone working in wood might be forced to carve and shape in order to depict such events. In other words, some of these visual effects can reflect *actual* process, while the same effect in another piece might be an *illusion* of that process or event.

Figure 73. Elin Elisofon, *Coyote and Case* (1976). Mixed media, 34″ × 14″ × 15″. (Courtesy of Braunstein Gallery)

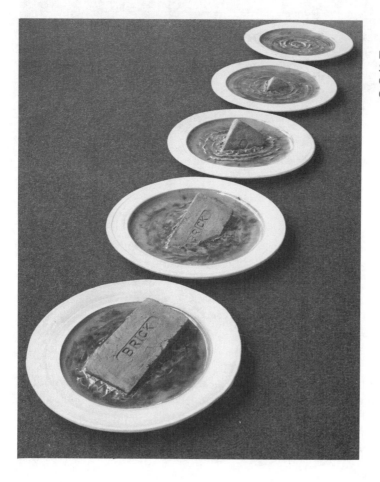

Figure 74. Robert Arneson, *Sinking Brick Plates* (1969). Ceramic. (Courtesy of Fuller Goldeen Gallery)

A piece like Manuel Neri's *Lucca No. 1* conveys a sense of the process of its execution through the range of effects from the unworked sections at the base, to the literal tool marks and scratches, to the refined surface of the left leg.

The idea of process in art can extend from the surface marks of hands and tools to artworks that are still in the process of change. By incorporating processes such as rot, chemical change, decay, or timing devices, an object can be made to radically transform itself through the passage of time. Some aspects discussed earlier in the book, such as the depiction of potential energy through the effects of literal or illusionistic tension, can also create a sense of impending events.

By showing as much concern for process as for the finalized object, many artists feel that they leave an opportunity open for more spontaneity and the fortuitous occurrence of "useful accidents."

In talking about all of the above we've been pointing out possibilities. The artist—in dialogue with his or her work—must decide what it requires. A sculptor or designer need not depict dramatic events to create dramatic effects.

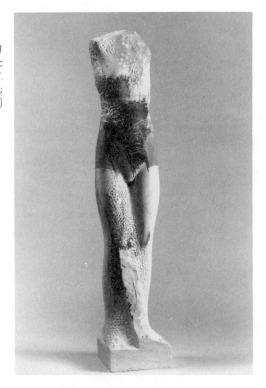

Figure 75. Manuel Neri, *Lucca No. 1* (1982–1983). Marble with synthetic enamel, 43⅛″ × 13″ × 13″. (Courtesy of John Berggruen Gallery; photo by M. Lee Fatherree)

6. UNIFIERS AND MODIFIERS

Creative design often results in the generation of unexpected combinations of forms, and materials placed in unexpected circumstances. In this chapter we explore some of the devices available to us for unifying these elements and modifying their character.

Beginnings, endings, and connections are discussed as crucial junctures, defining the relationships between the elements within an object and helping to shape the relationships between objects and the space around them. These junctures can play a crucial role in determining the ultimate character of an object.

Surface, as the outer barrier of form, often sets the tone for our initial understanding of objects. We consider some of the qualities of surface that are under our control and discuss their effects.

Finally, we discuss context, exploring the ways in which scale and presentation determine the interaction of objects with their environments and our responses to them.

Figure 76. Mike Baur, *Prairie Till* (model) (1984). Cast concrete, 12″ × 32″ × 9½″; finished work (1985), 6′ × 16′ × 5½′. (Courtesy of Zaks Gallery)

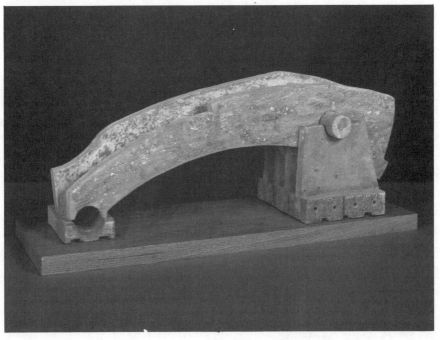

Beginnings, Endings, and Connections

It might be said that the outer boundaries of an object are where it begins and ends. The edge of a plane, or the tapering end of a linear element can command the attention of the viewer. While it may be clear that an artist or designer must decide how some element of a piece will intercept, or meet, another element or part of the piece, the maker must also decide how those various elements will begin and end.

Will a sweeping linear element end bluntly, or will it taper? Will it splay outward, or appear broken?

Will the edge of a planar element be knifelike or will it be softly rolled? Will it be roughly cut or serrated?

Will an object meet the ground plane with a sense of great force or mass, or will it touch down with delicacy?

Sam Hernandez's *Wood Krell* provides a good example of attention applied to a wide range of details. In the linear element we are aware of

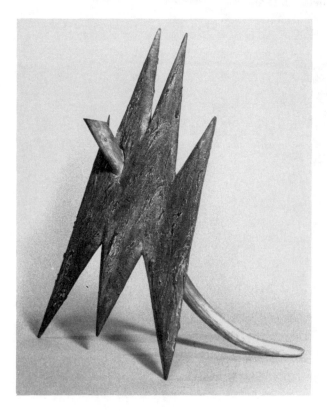

Figure 77. Sam Hernandez, *Wood Krell* (1981). Redwood, elm, gesso, and pigment, 31″ × 21″ × 16″. (Courtesy of Rena Bransten Gallery)

the contrast between the soft rounded end of the "tail" resting on the ground and the sharply cut off horizontal surface of its upper end. This contrasts with the aggressively shaped planar element. The points of the plane cut into the space around the piece, creating visual activity. This is enhanced by the tension of the middle point at the base of the plane, which is barely suspended above the ground plane.

In Ron Nagle's *Blue Sabu* we respond to a variety of contrasts between the bulbous form of the body and two more linear tapering volumes. One pushes out into space, while the other, although longer, turns back on itself, making subtle contacts with the other forms. We also pay special attention to the areas where various parts of the form emerge from one another. An additional contrast is established by the wavy overhang separating the piece from the ground.

One factor that often distinguishes successful work is the attention paid to seemingly small details. Aside from meeting the necessities of engineering, the joints or junctures within a piece offer opportunities to create a range of aesthetic effects.

Figure 78. Ron Nagle, *Blue Sabu* (1984). Ceramic, 2½″ × 2¾″ × 1¼″. (Courtesy of Rena Bransten Gallery; photo by M. Lee Fatherree)

The various elements of Michael Todd's pieces appear simply to be placed upon one another. While no attempt is made to hide the connections, they are kept as small as possible; this encourages us to sense potential for movement and rearrangement within the sculpture.

Figure 79. Michael Todd, *Shiva's Dance VII* (1983). Stainless steel, 43″ × 40½″ × 16″. (Courtesy of Klein Gallery)

William Wiley's *One Person Band for Thus Ain't* has an abundance of detail in its connections, which contributes to the establishment of a consistent character within the work. The seemingly casual connections within the piece work together to enhance our awareness of it as an assemblage of disparate elements.

Figure 80. William T. Wiley, *One Person Band for Thus Ain't* (1983). Mixed media, 62" × 37" × 27". (Courtesy of Fuller Goldeen Gallery; photo by M. Lee Fatherree)

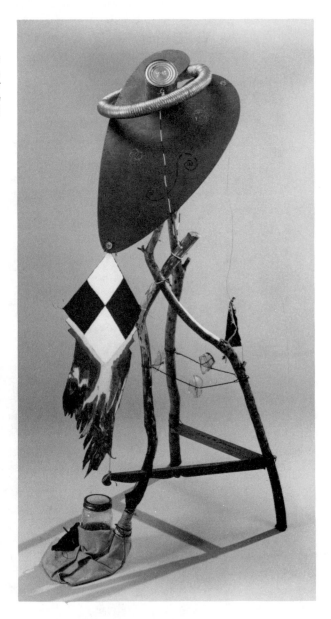

Sometimes pleasing or interesting results come from simply engineering a junction well. However, an artist may elect to create various visual effects that are independent of engineering necessity. For instance, an artist may choose to suggest past or future events; or to create tension, a sense of whimsy, or a feeling of precariousness.

Whereas the connections are physically required to hold the Todd piece together, Morse Clary uses them as the primary source of tension, energy, and interest in his work. His connections have no function in the physical structure of the piece.

Figure 81. Morse Clary, *Bound Form* (1982). Walnut and bone, 20″ high. (Courtesy of the artist; photo by Cathy Clary)

Surface

Literally speaking, any visible part of an object has surface area. For purposes of our discussion, however, surface is an area made significant by whatever treatment the artist or designer has applied to it. Any part of an object that is large enough in area to compel visual attention must be considered in terms of its surface as well as its form.

The quality of a surface may be the result of direct action by the artist in controlling or embellishing it. It may also be determined by the nature of the materials employed in the making of the object.

How an artist chooses to treat the various surfaces of a sculpture amounts to much more than merely detailing or putting a finish or patina on an object. Surface effects alone can determine a number of formal aspects of a piece. Perception of an object as heavy or light, as solid or hollow, as fragile, as luminescent, as static or active, can be strongly affected by the nature of its surface.

Surface treatments such as color and texture can unify widely disparate elements. Additionally, color or texture as camouflage can serve as a unifier of elements.

Conversely, contrast in color, texture, or surface can serve to differentiate the various elements of an object. Surface regularities and modulations may be used to create rhythms. Surface effects or colors may be used in the transitioning of various objects into one another.

Figure 82. Richard Shaw, *Two Books with a Pipe* (1980). Porcelain with decal overglaze, 9½″ × 8½″ × 4″. (Courtesy of Braunstein Gallery)

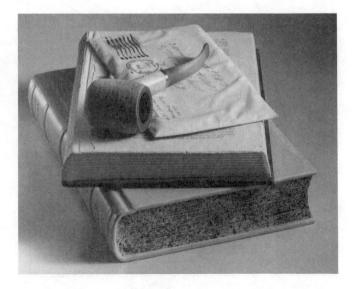

TEXTURE

Texture may be thought of as any varying feature of surface that is relatively uniform over an area and that is perceived as a whole rather than as a series of discrete elements. It is to a certain extent dependent on scale and context.

Anything from a finely etched or scratched pattern to mountainous protuberances can function as texture. Texture can enrich a surface or disguise material, break up light, create patterns of highlight or shadow, or make surface tactilely inviting or repulsive. Texture can be actual or can be created illusionistically by means of color. Texture may be created by physically altering a surface—cutting, incising, sanding, carving—or by adding materials, as in flocking, veneering, appliqué, etc.

Figure 83. Event versus texture.

David Middlebrook's stone sculptures rely on the contrasts between natural and man-made textures. Ron Nagle's *Smoke Stack Lightnin'*, while it has subtle variations in texture, relies on color for contrast with the forms. In both this piece, and *Blue Sabu*, texture serves a unifying function.

Figure 84. David Middlebrook, *Static Reign* (1984). Yellow siena, Italian serpentine, and red travertine, 40½" × 14½" × 11". (Courtesy of Klein Gallery)

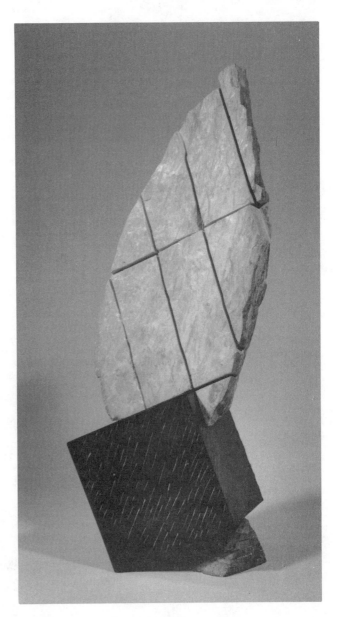

Figure 85 (left). David Middlebrook, *She Stone* (1984). Marble, 26″ × 23½″ × 5″. (Courtesy of Klein Gallery)

Figure 86 (right). Ron Nagle, *Smoke Stack Lightnin'* (1984). Ceramic, 3¼″ × 3¼″ × 1⅜″. (Courtesy of Rena Bransten Gallery; photo by M. Lee Fatherree)

In the case of Ken Little's *Poke*, the shoes create a textural field that both defines and breaks up the surface of the piece. The shoes exist on the boundary between their literal identity and their function as texture.

Figure 87. Ken Little, *Poke* (1982). Mixed media, 33″ × 76″ × 24″. (Courtesy of Rena Bransten Gallery; photo by M. Lee Fatherree)

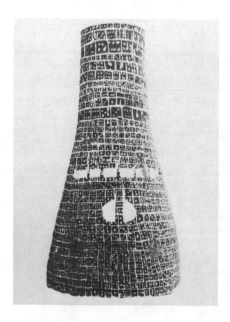

Figure 88. Robert Brady, *Snake Eyes* (1978). Stoneware and glaze, 4' 4" high. (Courtesy of Braunstein Gallery)

Chillida's *Cross* (Figure 33) gains a sense of age, permanence, and solidity from its texture. Robert Brady's *Snake Eyes* is an example of illusionistic texture created by applied pattern.

Figure 89. Dennis Gallagher, *Untitled* (1980). Ceramic, 84" × 16" × 12". (Courtesy of Rena Bransten Gallery; photo by Roger Gass)

COLOR

Many of the principles that are presented in courses on color theory and practical color applications for painters and graphic designers can be applied directly by artists working in three dimensions.

Observation will reinforce such common truths as, dark colors increase visual mass, and intense colors advance, while muted colors recede.

An artist creating objects that are frontally oriented, such as wall constructions, will find much of value in the study of two-dimensional design, composition, and color theory. We will restrict our considerations of color to those aspects of its usage that are particular to work in three dimensions.

David Middlebrook's stone sculptures (Figures 84 and 85) take advantage of different natural colors in the stone to enhance, change, or create contrasting effects.

Chillida achieves color changes by using patinas (Figure 33).

Color can obscure or reveal the nature of material. For example, pigmented oil can be used to bring out or to conceal the grain of wood. Color can be used to accentuate texture or to create an illusionistic texture. Color can contrast, or it can help join a sculpture to its surroundings. Color can unify disparate materials, forms, or textures. Color can create activity, rhythm, or a sense of movement. Manuel Neri uses paint freely, never denying the physical materiality of his work.

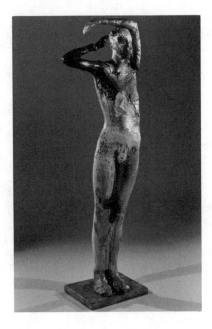

Figure 90. Manuel Neri, *Untitled Standing Figure No. 4* (1980). Bronze with enamel, 69½″ × 22½″ × 13¾″. (Courtesy of John Berggruen Gallery; photo by M. Lee Fatherree)

John Buck's *Between the Wars* uses color to visually unite elements that are physically separated. When viewed from a certain angle, the vertical two-legged plane "locks in" with the large square plane behind it (see Figure 92).

Figure 91. John Buck, *Between the Wars* (1985). Mixed media, 7½′ × 7′ × 3′. (Courtesy of Fuller Goldeen Gallery)

Figure 92. Line sketch of John Buck's *Between the Wars*.

David Simons uses color in another way. In *Clark,* color is used to break up the surface, camouflaging the form. In Robert Hudson's *Moon Rock,* color serves not only to break up the surfaces but also to create new rhythms and patterns.

Artists using concrete, resins, and amalgams can mix in color before their work takes its final form. When an artist makes the method of application of a pigment obvious (brushstrokes, poured streaks, etc.), not only is process revealed, but color is made into a surface feature. However, an artist may choose to apply surface color in such a way that an object seems to be of a color through and through.

Figure 93. David Simons, *Clark* (1982). Terra cotta, 46″ × 46¼″ × 24″. (Courtesy of Zolla/Lieberman Gallery)

Figure 94. Robert Hudson, *Moon Rock* (1982). Steel/paint, 36″ × 20″ × 8″. (Courtesy of Fuller Goldeen Gallery)

Some artists working in the sculptural realm give color secondary importance in the creative process. They allow choice of materials and, occasionally, happenstance to determine color. This is not to say that these artists give little importance to color. They simply have decided not to become involved in making elaborate choices about color.

REFLECTIVITY AND TRANSPARENCY

A highly reflective surface—such as chrome or a high-gloss polished finish, paint, or plastic film—can make an object very reactive to its environment. Not only will the piece literally reflect its surroundings, its perceived surface will be sensitive to light and will change in response to movements of the viewer or of other elements in its environment. This is well demonstrated in Aldo Casanova's *Instant*. Transparent or translucent works, such as William Carlson's installation, are also highly responsive to their surroundings.

Figure 95. Aldo Casanova, *Instant* (1969). Bronze, 24″ × 18½″ × 10″. (Collection of Whitney Museum of American Art; gift of the Louis Comfort Tiffany Fdn.; acq. #69.93; photo by Geoffrey Clements)

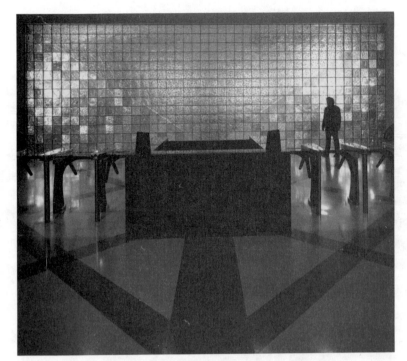

Figure 96a. William Carlson, *Optional Refractions* (1984). Glass, 14' × 42'; installed at Chicago Board of Options Exchange. (Courtesy of the artist; photo by William Crofton)

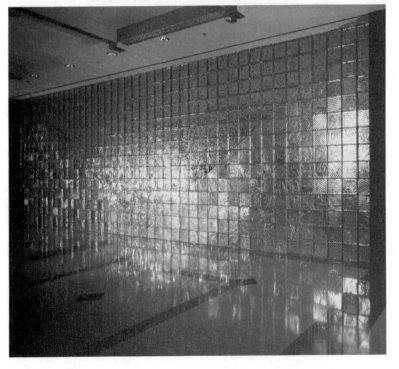

Figure 96b. William Carlson, *Optional Refractions* (detail). (Courtesy of the artist; photo by William Crofton)

The opposite of a highly reflective finish is a matte or nonreflective finish. In this case, the viewer's perception will be less affected by reflection. In general, a matte surface clarifies volume and diminishes the influence of surface as a distraction to the overall qualities of form. A matte finish will unify the surface, giving a greater feeling of solidity and mass. Conversely, a polished surface will often show any waves, dents, or imperfections in its surface, however slight. Note the effect of the different levels of reflectivity in John Roloff's *Land Monitor Model/ Cave*.

Figure 97. John Roloff, *Land Monitor Model/Cave* (1981). Ceramic material and paint, approx. 2' × 18'. (Courtesy of Fuller Goldeen Gallery; photo by M. Lee Fatherree)

Context: Scale and Presentation

Scale is strongly affected by context. A sculpture that seems gargantuan inside of a gallery may seem smaller in an open plaza surrounded by tall buildings. When an artist seeks to achieve heroic scale, early attention is given to the ultimate placement of the work.

Installation work, such as Edward Mayer's *Stated View*, is often scaled to a specific interior space. Sometimes, as in the work of Judy Pfaff, the interior space is literally incorporated into the installation.

Figure 98. Edward Mayer, *Stated View* (detail of installation, 1984). Mixed media, Madison Art Center, Madison, Wisconsin. (Courtesy of Zolla/Lieberman Gallery)

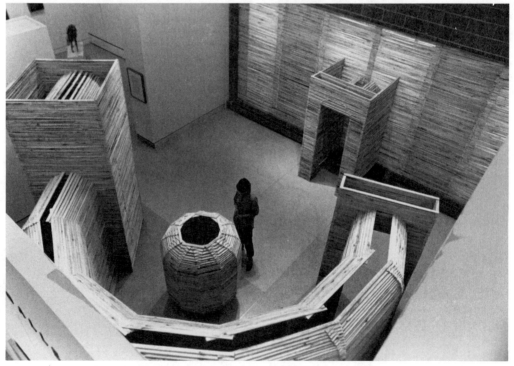

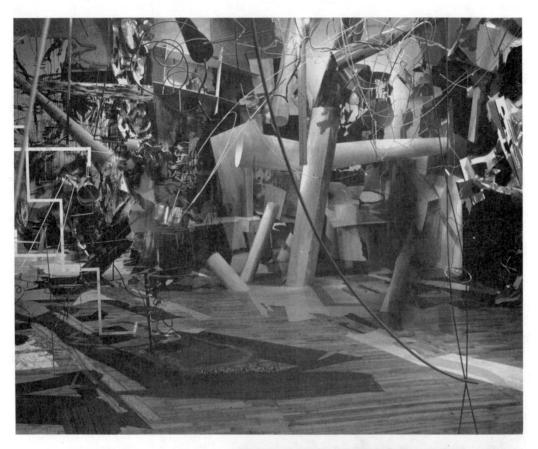

Figure 99a. (above) Judy Pfaff, 3-D (gallery installation, January 1983). Mixed media. (Courtesy of Holly Solomon Gallery)

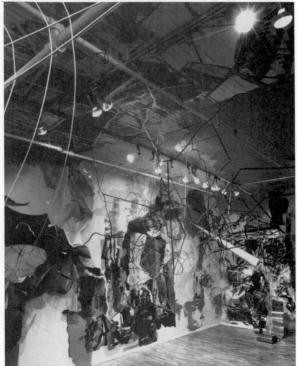

Figure 99b. Judy Pfaff, 3-D (detail). (Courtesy of Holly Solomon Gallery; photo by D. James Dee)

Representations of familiar objects that are only slightly larger or smaller than their normal size create a sense of unease or interest by shifting our image of our own size in relation to the world around us. Robert Arneson's self-portrait, rendered at about one-and-a-half times life size, takes advantage of this. Extremely miniature or very large translations of scale are often less unsettling.

Figure 100. Robert Arneson, *Way West of Athens* (1983). Bronze head on ceramic pedestal, 73" × 24". (Courtesy of Fuller Goldeen Gallery; photo by M. Lee Fatherree)

An interesting shift occurs when a sculpture incorporates extreme contrasts in scale within itself. Barbara Zucker's two renderings of the the same form at radically different scales are interesting in this regard. As scale is related to context, these juxtapositions challenge our expectations of appropriate scale. This can also be seen in the piece by Don Shaw. In both of these cases the larger element serves in some ways as a base for the smaller element, focusing our attention on it and isolating it from its surrounding environment. In Rick Ripley's piece, a relative scale is established by the human figure.

Figure 101. Barbara Zucker, *Turret on Wheels* (1984). Painted wood and casters, 108½″ × 21″ × 26″. (Courtesy of Pam Adler Gallery; photo by Pelka/Noble Photography)

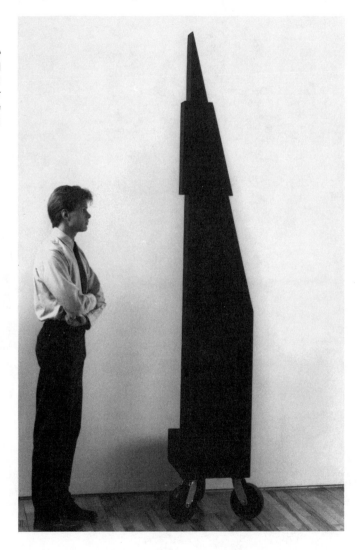

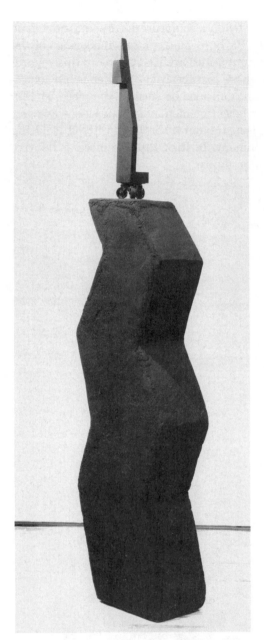

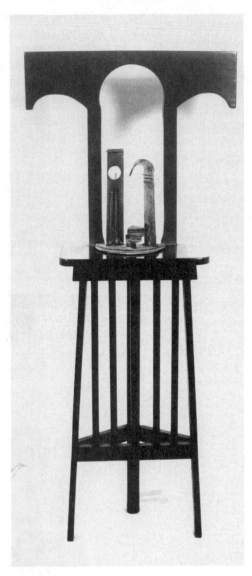

Figure 102. Barbara Zucker, *Leftover on Wheels* (1984). Paint, wood, cement, and casters, 60″ × 15″ × 6½″. (Courtesy of Pam Adler Gallery; photo by eeva-inkeri)

Figure 103. D. E. Shaw, *Il Seat of Power Series* (1984–1985). Bronze and lacquered wood, 54″ × 12″ × 22″. (Courtesy of the artist and Moody Gallery)

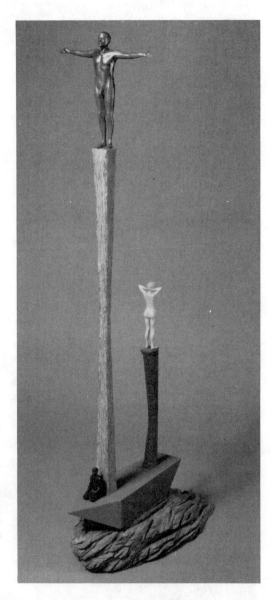

Figure 104. Rick Ripley, *View of the Garden* (1985). Basswood, pine, fir, cast urethane, and oil, 66" × 14" × 32". (Courtesy of the artist; photo by Gary Colby)

A distinction may be made between bases or support systems that are an integral part of the work and those that serve as buffers separate from the piece itself. Arneson's work functions on both sides of this divide. Works like Richard Kelley's *A Question of Location* and Beverly Pepper's Dartmouth site piece are totally integrated into their environment, penetrating the earth as well as growing out of it.

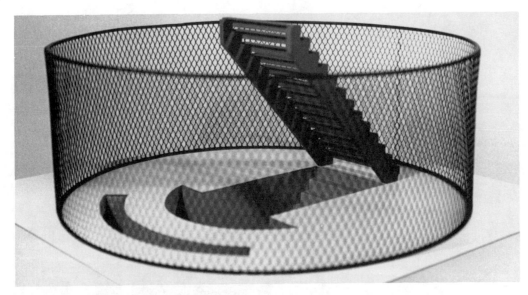

Figure 105. Richard Kelley, *A Question of Location.* Aluminum and wood, 20″ × 20″ × 12″. (Courtesy of Klein Gallery)

Figure 106. Beverly Pepper, *Thel* (installation view, Dartmouth College, 1976). (Courtesy of André Emmerich Gallery)

The presentation of a piece can serve to separate it from the larger environment, creating a self-referential universe in which it can exist. In Christine Bourdette's work the activity and smaller parts are all related to a contained setting. Will Maclean's *Museum for a Seer* uses an enclosed case to isolate the interior event under glass.

In most cases, unless the artist intends to make the base an integral part of the artwork, it should be made a neutral device. Its job is to present and accentuate the work with minimum fuss and distraction. Often this means a simple geometric volume constructed to look solid, cleanly crafted, and painted in a neutral color.

Figure 107. Christine Bourdette, *Damn the Torpedoes* (1983). Painted wood and tin, 31½″ × 9″ × 9″. (Courtesy of Klein Gallery)

Figure 108. Christine Bourdette, *Are We There Yet?* (1983). Paint and paper on wood, 22″ × 28″ × 9″. (Courtesy of Klein Gallery)

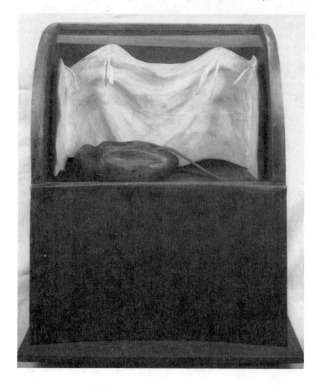

Figure 109. Will Maclean, *Museum for a Seer* (1984). Mixed media construction, 52 cm × 43 cm × 25 cm. (Courtesy of Leinster Fine Art; photo by Miki Slingsby)

7. ANALYSIS

In this last chapter is presented a protocol for analysis—a series of questions to ask and answer about your work and that of others. You will remember from the chapter on conceptualization that the last step in the creative process is analysis. This chapter will help you to complete the cycle.

1. What was the artist or designer trying to accomplish? How did they define the problem for themselves? What were their goals?

2. How do we perceive the piece? What is the total field it encompasses? Which aspects of that field are explicit and which are implicit?

3. Do we break the piece down into parts for understanding? If so, how are they grouped—by similarity, proximity, color, material, direction, gesture, or other means? Do the groupings overlap? How?

4. Are some elements or parts of the object more important than others? Which ones? Could any elements or parts of the piece be removed without drastically altering its character? If so which ones and how many?

5. If you were to do a series of variations on this piece, what form would they take? Which elements would you retain and which would you modify?

6. Is the scale of the piece appropriate? How would it be changed if it were much larger or smaller?

7. Is the presentation of the piece appropriate? How does it relate to its surroundings? What would it be like in a different environment? In what ways would its current setting be altered if it were removed?

8. Is there a good balance between craftsmanship and concept? Does the quality of construction add or detract from the ideas in the piece?

9. Does the piece change our visual perceptions about materials or form? Does it surprise us in any way?

10. What aspects of the piece would be appreciated fifty years ago or fifty years from now?

11. If you were to execute a series of objects related to this project, how would you group them for an effective presentation?

12. Can you think of the smallest possible change that might significantly alter the character of this project?

13. Were there any accidents or unforeseen circumstances that were successfully incorporated into the work? How would the work have been different had these events not occurred?

14. How would the appearance and effect of the piece be altered if it were rendered in another medium?

15. Does the piece have some elements or features which seem to be "favorites" of the artist? Do they work to the benefit or detriment of the project as a whole?

16. What aspects of the piece are open to differing interpretations by the viewer? Do they dilute the strength of the object or increase its universality?

17. Beyond the expenditure of physical and mental effort, has any part of the artist's personal being been invested in this project? In what way is this reflected in the work?

18. Is it possible to conceive of an object that would be the formal and/or conceptual opposite of the piece? What form or forms would this opposite take?

19. Does the object have any gestural or emotional characteristics? Is it somber, whimsical, cynical, uplifting, . . . ? From what elements do these qualities arise?

20. Does the object have any narrative content? Does it tell a story or make a statement? How?

PROJECT IDEAS

In this section are presented the bare bones of a number of projects that can be used to explore the various ideas presented in the text. We have attempted to keep the projects as open and general as possible, to enable instructors and students to customize for their own particular circumstances, needs, and goals. You may find that many of the projects lend themselves to being combined. Another possibility is to use the products of one project as the raw materials for the next project.

1. Surface

Take a number of ping pong balls and alter their surfaces in as many ways in order to create the greatest contrasts in perceived mass, weight, volume, softness, hardness, etc.

2. Space Frame

Use a prescribed volume (e.g., one cubic foot), arrange a finite number (three to seven) of visual elements (e.g., one organic element, two linear elements, one geometric element, etc.) with a specific goal in mind (e.g., to create as much drama or tension as possible). Elements might be placed throughout a framework or be oriented to a single plane.

3. Unification

Take three or more objects that are dissimilar in shape and/or material (objects with as little as possible in common) and unify them into a single coherent object. Possibilities include using surface, physical orientation, selective emphasis of common characteristics, etc.

4. Intermediate Connection

Take two objects and fashion a third element that will physically connect them together. The connection should be accomplished in such a way that it is the most important part of the piece.

5. Presentation

Take a common object (such as a coffee cup) and devise a means of presenting it that will cause it to be perceived as an object of special importance or value. The object itself should not be altered in any way.

6. Embellished Object

Take a utilitarian object (wooden objects are ideal) and embellish its surface to the extent that surface becomes more important than shape or form.

7. Scale Translation

Find or fabricate an object of intimate scale (matchbox size) that is both visually and tactilely interesting. Reproduce the object in another medium at a much larger scale.

8. Recipe

Starting with a simple object (such as a block of plaster, wood, or styrofoam), serially perform a recipe of actions to dramatically alter its form. A possible recipe follows:

Step 1: Remove one corner from the object.

Step 2: Make two incisions in the object.

Step 3: Create a passageway (a hole) through the object.

Step 4: Apply a texture to one-third to two-thirds of the surface.

Step 5: Take what further action the object "needs."

9. Metamorphic Object

Create an elongated volume with character that smoothly changes or metamorphoses from one end to the other (e.g., changing from a crisp sharply edged form to a soft amorphous form).

10. Metamorphic Set

Create a series of objects that shows a progression or rhythmic change in terms of shape, scale, apparent age, color, or surface, etc.

11. Illusory Event

Create an object of perceived softness that appears to be penetrated by an object of perceived hardness.

12. Implied Volume

Create a recognizable image of a known three-dimensional object using a minimal amount of linear and/or planar material to effectively imply the volume of the original object.

13. Illusion Versus Reality

Take two similar volumes and segment one of them using illusionistic means (e.g., surface treatment) and the other one using physical means (e.g., cutting).

14. Illusionary Surface

Use subtractive methods to make a simple solid object appear to be bound, wrapped, or festooned with other materials.

15. Enclosure

Take a small form and create a larger form with a negative space that will contain, house, or seem to nurture the smaller object in an unexpected manner.

16. Modular

Choose a simple structural module (e.g., bricks or blocks) and combine or arrange them into a single structure with at least two contrasting attributes (e.g., stability and precariousness). This project could be done as a group project at large scale.

NOTES

Materials List

It is not the intention of this book to survey all the materials used by artists. The illustrations should give an idea of the range of possibilities. Obviously some materials are more suitable for achieving certain visual goals than others.

Perhaps the most important thing to consider in the choice of materials is the artist's personal affinity for the material chosen.

Plastic Materials

Clay

Papier Mache

Direct Plaster

Structolite (perlited plaster)

Oil-based clay

Flour and salt

Oven bake clays

Epoxy putty

Adhesives with filler (such as wood glue with sawdust)

Castable Materials

Plaster

Slip clay

Resins

Resin with fillers (such as wood chips or powdered metal)

Concrete

Metals

Paper

Carvable Materials

Wood

Cured Plaster

Stone

Salt blocks

Insulating brick

Firm clay

Soapstone

Soap

Bone

Micarta

Laminated homasote board

Styrofoam (laminated blueboard)

Linear Materials

Welding rod

Metal tubing

Wire

Cardboard tubes

String

Rope

Monofilaments (fishing line)

Plastic rod and tubing

Sticks and twigs

Wood doweling and strips

Planar Materials

Fabric

Sheet metal

Metal and plastic screening

Cardboard

Paper

Plywood

Masonite

Glass

Plexiglass

Sheet plastics

Thin wood (veneer or balsa wood sheets)

Homasote

Styrofoam blueboard

Plastic films

Leather

Birch bark

Rubber sheet (from used inner tubes)

Elastic or stretch materials

Sources

Materials are where you find them. One of the pleasures of working in three-dimensional design is the opportunity to work with "real" materials in addition to traditional art supplies. Following is a short list of interesting sources for supplies.

Lumberyards

Builders' supply centers

Hardware stores

Hobby shops

Variety stores

Bait and tackle shops

Marine supply

Fabric stores

Discount stores

Surplus stores (Army and Navy)

Scrapyards

Junkyards

Thrift shops

Yard sales

Kitchens, attics, garages, basements

Alleyways

Art supply stores

Electronic supply shops

Auto supply shops

GLOSSARY

Actual process: the means by which an object is constructed, or the activity taking place in the piece.

Alignment: arrangement along an axis.

Amorphous: without definite form; lacking in structure.

Axis: a line, real or imagined (explicit or implicit), around which the material that composes an object appears to be organized.

Cantilever: an element which projects horizontally into space, supported at only one end.

Composition: the arrangement or structuring of various elements.

Contour: the outline of an object.

Depiction: a representation.

Direction: the line (explicit or implicit) along which an object or element seems to be pointing or moving.

Disparate: separate, distinct, dissimilar.

Explicit form: matter occupying space.

Explicit line: matter aligned upon an axis.

Explicit plane: matter distributed upon a surface.

Explicit volume: matter occupying space.

Form: three-dimensional object.

Gesture: the expressive and evocative qualities that result from the arrangement of forms in space.

Grouping: the perceptual gathering of several elements.

Ideation: the process of coming up with ideas.

Illusion: appearance which is contrary to fact.

Illusionistic texture: surface which appears to have a texture that it does not have physically—as in wallpaper printed to look like bricks.

Implicit form: space—not occupied by matter—which is perceived as coherent as a result of the interaction of surrounding elements of form.

Implicit line: space aligned along an axis as a result of the interaction of surrounding elements of form—usually the result of the interaction of points.

Implicit plane: space aligned along a surface as a result of the interaction of surrounding elements of form—usually the result of the interaction of lines.

Implicit volume: space—not occupied by matter—sensed as coherent and resulting from the interaction of surrounding elements of form—usually planes.

Irregular shape: a shape lacking uniformity, such as a shape with varying angularity.

Juxtaposition: adjacent placement of visual elements.

Line: that element of form which is primarily understood in terms of its length.

Maquette: a model (at small scale) for a larger sculpture.

Mass: the perceived weight or density of an object.

Matte finish: an opaque, nonreflective surface with a relatively smooth texture.

Model (noun): a three-dimensional sketch.

Model (verb): to manipulate and form a plastic material such as clay.

Moderate: to limit or restrain.

Modifier: something which changes the perceptual effect of form in space.

Modulation: smooth transition or change.

Negative shape: in two-dimensional design, an area surrounded by other activity which creates a sense of closure, giving the shape coherence.

Opaque: having the property of blocking light.

Organic: having shape or form referential to biological structures, often refers to a shape or form that has structure without angularity.

Patina: a surface composed of a thin film of semitransparent variegated color, which can often convey a sense of age or use.

Perceived movement: sensed movement in an object which is actually static.

Plane: that element of form which can be described in two dimensions, predominantly characterized by surface.

Positive shape: in two-dimensional design, those elements which are actually represented, by contrast in color or value.

Potential energy: the result of arranging form in such a way as to suggest a possibility of falling or other movement.

Primary axis: the major axis of a form or object; for example, the spine might be thought of as the primary axis of the human skeleton.

Radiation: the quality of form which activates an envelope of space around it.

Referential: having the property of resemblance to an identifiable object.

Reflectivity: the quality of surface which turns light back into space, ranging from low (as in a matte surface) to high (as in a mirror).

Regular shape: a shape with uniform properties that conform to certain prescribed rules; for example, a square must have four equal sides and 90° angles.

Rhythm: the quality of form which results from regular intervals or repetitions.

Scale: size relative to other elements within or outside of an object.

Selective vision: the phenomenon of "filtering" visual events which do not relate directly to what the viewer is looking at.

Sketch: a preliminary drawing or model used to explore possibilities for a finished object.

Spatial orientation: the relationship of an object to the ground plane and to other objects in its vicinity.

Static: without movement.

Surface: the planar areas of an object which are exposed to the viewer.

Textural field: a broad area with a unified texture.

Texture: the tactile aspect of surface.

Translucent: semitransparent; able to pass diffuse light.

Transparency: the quality of material which describes its ability to allow light to pass through it.

Unifier: that which allows the viewer to visually or conceptually connect or group various components of an object.

Visual density: perceived or apparent mass.

Volume: defined or coherent space.

Working drawing: a detailed sketch used to direct the making of an object.

INDEX